Collage**ART**

A STEP-BY-STEP GUIDE & SHOWCASE

First published in the United States of America by:
Quarry Books, an imprint of
Rockport Publishers, Inc.
33 Commercial Street
Gloucester, Massachusetts 01930-5089
Telephone: (978) 282-9590
Fax: (978) 283-2742

Distributed to the book trade and art trade in the
United States by:
North Light, an imprint of
F & W Publications
1507 Dana Avenue
Cincinnati, Ohio 45207
Telephone: (800) 289-0963

Other Distribution by:
Rockport Publishers
Gloucester, Massachusetts 01930-5089

ISBN 1-56496-640-2

10 9 8 7 6 5 4

Designer: Lehman Graphic Design
Additional photography: Karen Gourley Lehman
Front cover collage: Rachel Paxton
Back cover images: Page 31 (background image);
Pages 29, 30 and 42 (inset images)
Printing in Hong Kong by Midas Printing Limited

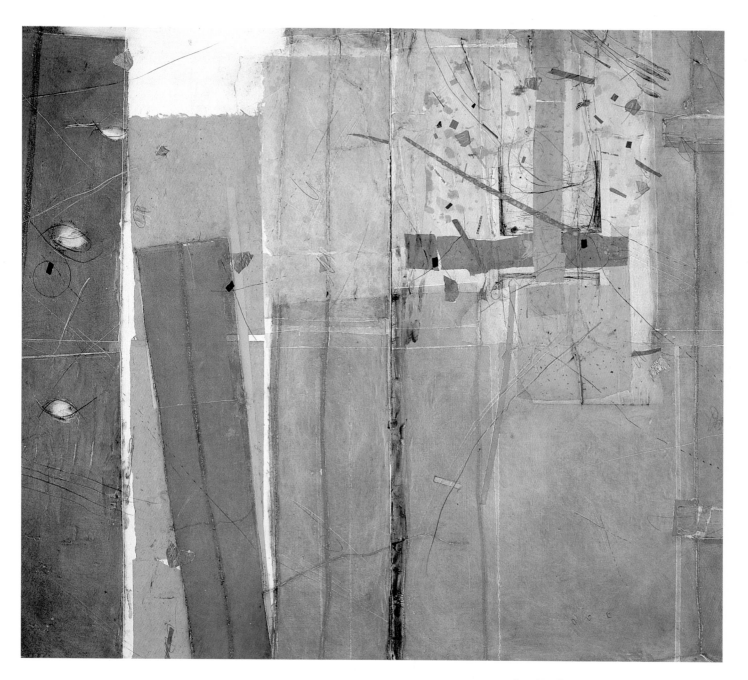

Jennifer Berringer
Minstrel
62" x 82" (157 cm x 208 cm)

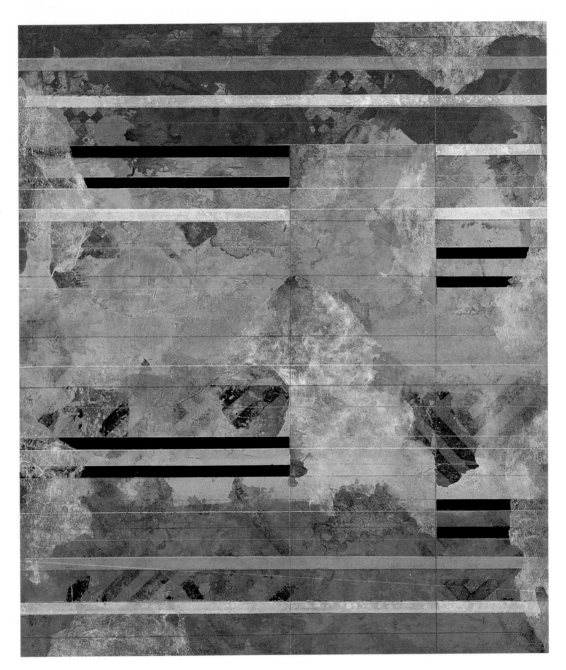

Robert Kelly
Kairos IV
Collagraphy with mixed media
39" x 32" (99 cm x 81 cm)

CollageART

A STEP-BY-STEP GUIDE & SHOWCASE

JENNIFER L. ATKINSON

QUARRY BOOKS
GLOUCESTER, MASSACHUSETTS

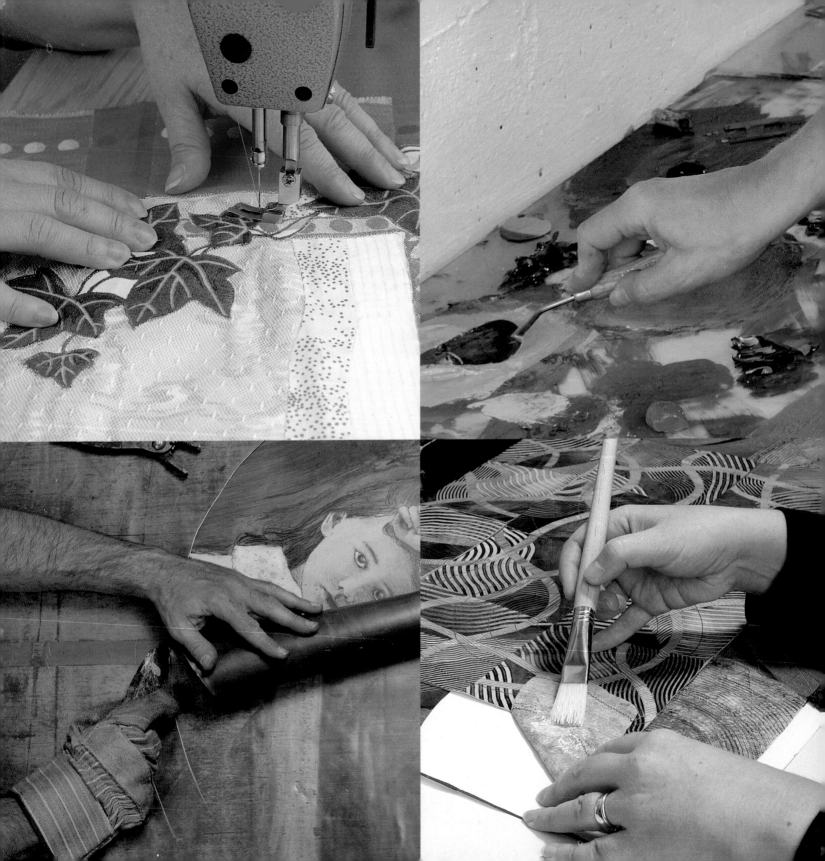

C O N T E N T S

JUL 2000

Nancy Rubens
19-19-19
Paper with mixed media
16" x 12" (41 cm x 30 cm)

ACKNOWLEDGMENTS

My thanks to my friends and colleagues, Meredyth Moses for her unflagging support and enthusiasm, and Julie Bernson whose passionate devotion to art and artists is always inspirational; to Judy Becker for her input in the fabric collage section; and to Susan Farrington for her help with the found object chapter.

For the technical assistance, thanks go to Amy Madanick, Casandra McIntyre and Drew Ellis of Rugg Road Papers in Boston, all of whom gave generously of their time, materials and knowledge. Also, thanks to Janice Delorey of Commercial Screen Supply in Avon, Massachusetts, who provided help and materials.

My thanks to all of the artists who have offered work for this book; to those whose work I was unable to include, I would like to extend an especially heartfelt thank you. I would like to remember the artist Eloise Pickard-Smith (1921-1995), whose work appears in the paper collage showcase.

Thanks also to Peter Schlessinger and the New Art Center in Newtonville, Massachusetts, a non-profit alternative space where curators are given an opportunity to organize shows under the auspices of the Curatorial Proposals program.

I would like to thank Rockport Publishers; Rosalie Grattaroti for having faith in a novice and Shawna Mullen, my editor. Thanks also to Caroline Graboys and my new colleagues at the Fuller Museum of Art who have waited patiently for my undivided attention.

Last, I want to acknowledge the contribution of my parents, Robert and Norma Atkinson, who have always supported my academic and artistic endeavors, and to my mother especially to whom this book is dedicated.

All photography by:
Dean Powell Photography
217 California Street
Newton, MA 02158
617-969-6813/617-969-7381 fax
except:
Jennifer Berringer for Jennifer Berringer
and
Todd Gieg for Ben Freeman
316 Summer Street
Boston, MA 02210
617-451-1337

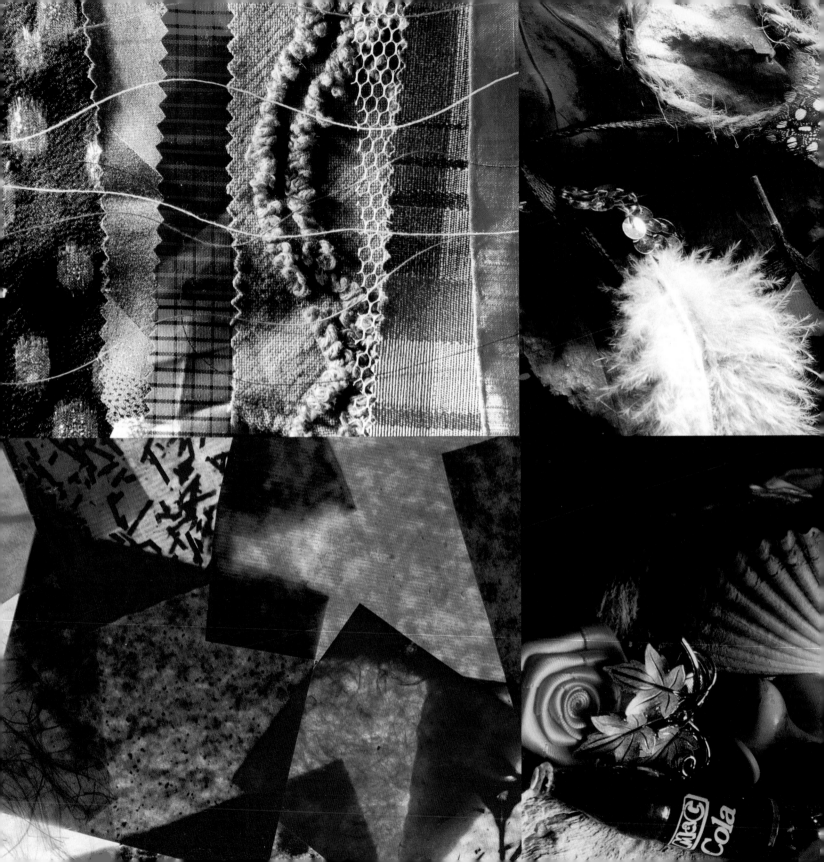

INTRODUCTION

Collage had a long, vital history as a folk art before it emerged as a fine art in the twentieth century. In Europe, Asia, and the Americas, all kinds of everyday materials were transformed into mementos and decorations: pictures made of matchsticks, straw, butterfly wings, or feathers; portrait silhouettes cut carefully from paper and framed; fancy paper Valentines garnished with bits of lace and cutout papers; and pressed flower arrangements. In the early 1900s, the modernist avant-garde adopted collage as a medium, making it an integral part of the evolution of modern art. It suited the modernists' radical reinterpretation of the picture plane (they rejected one-point perspective and the attempt to portray "real space" in two-dimensional work). Collage's celebration of common materials, typically considered beneath the purposes of fine art, also appealed to them—they wished to create art that could be reproduced easily, made from readily available materials.

Collage continues to appeal to professional artists (even those who specialize in other media), and amateurs as well, because it presents a personal, spontaneous way of working with materials that are easy to obtain. A wealth of books on the discipline of collage is available to those who wish to study its origins and development. This book provides information on paper and fabric collage, collagraphy, and found object collage, to assist and inspire both those who are just discovering the medium of collage, and those who would like to add to their knowledge and skills. As you will see, the creative possibilities of working with collage are infinite.

A SHORT HISTORY
of Collage

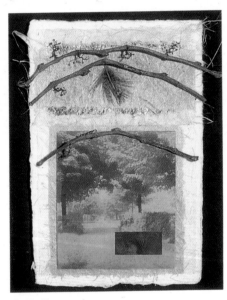

C. P. Kunstadt
In Reverence
Collage with mixed media
4" x 6" (10 cm x 15 cm)

Ellen Wineberg
White Bird on Black
Collage with oil and shards on wood
12" x 15" (30 cm x 38 cm)

In 1912, Pablo Picasso and Georges Braque began making paper collages according to the principles of cubism. Their two-dimensional collages employed newspaper clippings, colored papers, tobacco wrappers, and wallpapers. They favored printed papers with trompe l'oeil patterns resembling materials such as wood grains and chair caning, and they often embellished their works with painted details or charcoal drawings.

Once the cubists adopted collage, other artists and movements recognized its potential. In Italy, the futurists used collage to convey the ideals of the machine age—speed, dynamism, and mechanization. Russian constructivists employed collage in the posters that heralded the Russian Revolution. Dadaists and surrealists of the 1920s stretched the boundaries of the medium, incorporating found objects, mixing elevated subject matter with mundane or earthy topics, and placing texts or headlines in unusual contexts to impart new meaning to them.

Marcel Duchamp, the most well known Dadaist, created "ready-mades," found objects to which he added text. His most scandalous ready-made, entitled *Fountain,* was fashioned from a urinal and bore this signature: R. Mutt. Duchamp also created collages that combined his own artwork with mass-produced images. Two other well known Dada artists, Kurt Schwitters and Max Ernst, used collage extensively. Schwitters integrated memorabilia from his personal life (tickets, newspapers, letters) into his collages. Ernst, deeply interested in the new field of psychiatry, employed the principle of automatism-suspending the conscious mind's control in order to release subconscious images. Collage enabled him to access these images and render them in his work. Ernst achieved subtle effects by exploiting the medium of paper, using tracings and rubbings, as well as damaging certain images in his work through peeling or tearing.

The works of Joseph Cornell form a watershed in the history of collage. He created arrangements of objects—old bottles, toys, trinkets—in small boxes (these three-dimensional collages are often called *assemblages*), as well as working with paper images. Surrealistic juxtapositions, such as the printed image of a human being's body topped with the head of a bird, are a

hallmark of his work. Though associated with the surrealists, he also cited the influence of Hans Christian Andersen's *Great Screen* (1662), which combined paper cutouts of outdoor scenes, architectural elements, and myriad faces on a large folding screen.

In the 1940s, abstract expressionists appropriated collage to express the pioneering spirit of the artist. Robert Motherwell adapted paper collage to generate abstract forms from materials such as wine bottle labels, soap boxes, book jackets, and cigarette packages, typically emphasizing torn edges. He considered collage to be a form of play, a medium that allowed him to be gestural and spontaneous. Robert Rauschenberg, however, used collage techniques to challenge the abstract expressionists' devotion to pristine surfaces and nonrepresentational themes in his "combine paintings" such as *Bed* (1955), which featured a mattress and bedclothes that have been painted.

Jasper Johns continued the development of collage in the 1950s with three-dimensional pieces often incorporating dartboards (their concentric circles recur as a motif in his work) and other large items, such as molds of heads. He frequently embellished these works with paint. During the pop art movement of the 1960s, collage artists focused on items representing pop culture, such as televisions sets, advertisements, telephones, comic strips, and food packaging— variously spoofing them, transforming them, or giving them an eerie life of their own. For example, Claes Oldenberg's large-scale soft sculptures re-create everyday objects in unusual materials, such as a huge ice cream cone rendered in fuzzy fabric.

More recently, neo-Expressionists have incorporated collage elements into primarily painted surfaces. Julian Schnabel, for example, has attached crockery to his painted canvases. Jeff Koons has continued to interpret elements of pop culture, as in his treatment of a balloon twisted into an animal shape and cast in ceramic with a metallic finish. Collage also well expresses the postmodern nonlinear view of time, in which fragments of the past can overlap with the present. The viewer can consider the meaning of an item in its original context as well as the ramifications of its new position.

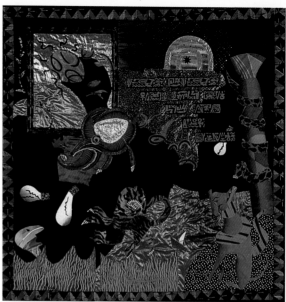

Clara Wainwright
Out of Order
Paper with mixed media
54" x 54" (137 cm x 137 cm)

Betty Guernsey
Every Time We Say Goodbye
Paper with mixed media
20" x 30" (51 cm x 76 cm)

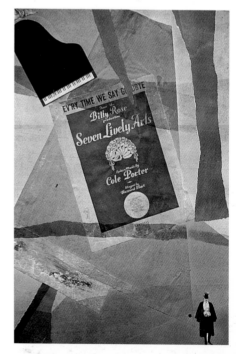

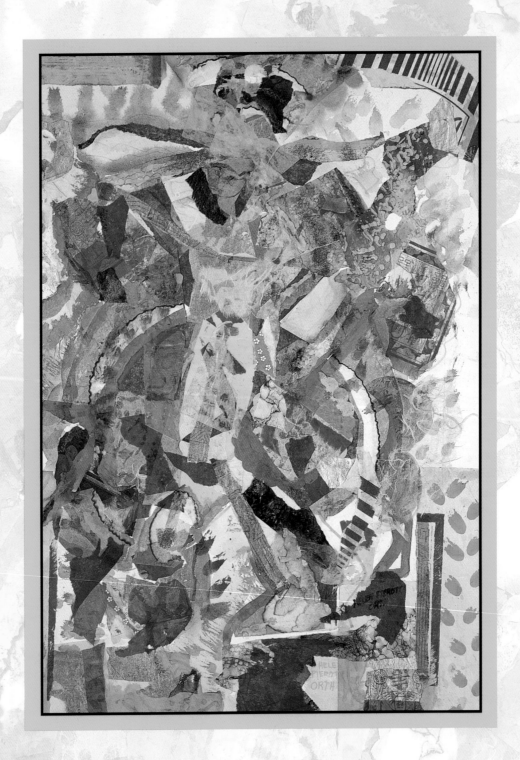

Paper
COLLAGE

Although there are many varieties of paper collage, they all begin with the same simple materials: pieces of paper and glue. These two everyday items offer nearly endless possibilities for combining colors, patterns, and textures. Paper collage is popular because its techniques are easy to learn and its materials are inexpensive and readily available. In addition to fresh sheets of colored or painted paper of various weights and textures, a host of common items may be recycled into collage, including magazines, newspapers, grocery bags, letters, tickets, gift wrap, confetti, receipts, paper towels, labels, train schedules, wax paper, posters, and so on. Artists who work in other media often layer old sketches, drafts, and leftover pieces of artwork into collage. The result may be a sophisticated work of fine art or a simple greeting card.

◀ **Helen Orth**
Collage Mystique
Paper collage
35" x 25" (64 cm x 64 cm)

▲ **Gordon Carlisle**
Leap
Collage with acrylic painting enhancement
5.5" x 3.5" (14 cm x 8 cm)

Collage artists may also manipulate paper to achieve a variety of effects. Folding, tearing, crumpling, cutting (perhaps with pinking shears), wetting, puncturing, and embellishing with lead pencil or paints can lend expressiveness and visual interest. Also, the arrangement of collage elements is as important as the selection of papers. Many people enjoy the spontaneous process of mixing the papers randomly until a pleasing composition is achieved. Still, a consideration of design basics—line, color, shape, pattern, size, value, and movement—will enhance the final product. In collage, the design process is simplified because the materials can be rearranged several times before they are glued down.

Paper collage had a long history as a folk art before emerging as a fine art in the twentieth century. For example, it was used to decorate twelfth-century Japanese calligraphic texts and nineteenth-century German greeting cards. Families of the Victorian period collected the ephemera of everyday life, including calling cards,

newspaper headlines, invitations, and greeting cards, and then arranged it in parlor scrapbooks—thus creating collage. During the twentieth century, paper collages gained prominence in the cubist, dadaist, and surrealist movements. At the same time, it continued its role as an approachable medium that excludes no one, celebrating the multiplicity of images, texts, and papers (commonplace, bizarre, humorous, and beautiful ones) that surround us.

This chapter features the work of contemporary artists Rachel Paxton and Karen L. McCarthy. Paxton approaches her collages without a precise subject in mind. She uses collage as a method of working, a process through which she arrives at an expression of an idea, feeling, or impression to share with viewers. McCarthy approaches collage from the opposite position. She begins with a definite topic or idea in mind and builds upon it. Both artists incorporate techniques from other media: Paxton uses painting, and McCarthy employs her background in sewing.

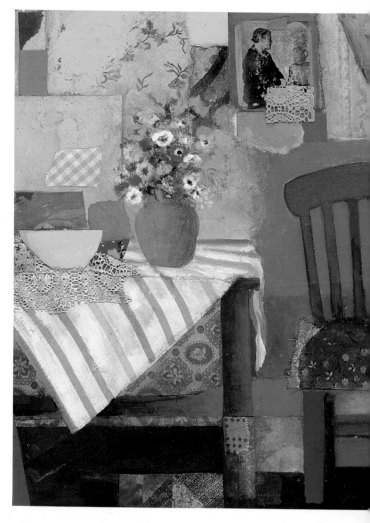

▲ **Timothy Harney**
Green Chair and Stolen Flowers
Paper with acrylic and mixed media
14" x 11" (55 cm x 46 cm)
Courtesy of the artist and Clark Gallery

Paper
MATERIALS

Although a primitive paper made of bark was

used by the people of Mexico and Central America in pre-Columbian times, paper that we would recognize as such today was developed in China, where papermaking evolved into a high art. Paper is composed of fibers that have been compressed into a compact web. Handmade paper has four deckle edges (uncut edges with a soft contour). Mold-made paper, created on a very long screen and then cut by machine, has two deckle edges. Machine-made paper, produced on huge screens and then cut, has no deckle edges.

Handmade papers are considered the finest. Mold-made and machine-made papers, even when produced from the same fibers, are generally inferior to handmade papers. Most handmade paper in the West is made from cotton linters (waste fiber remaining after ginning) and cotton rags (longer, tougher waste fiber remaining after the thread-making process—hence the name rag paper). These papers offer a wide variety of texture, color, and finish. A typical sheet might be 22 by 30 inches or 32 by 44 inches in dimension, though much smaller sizes can also be found. Unique handmade paper might feature wildflowers, shredded currency, or glitter, which can lend a unique effect to a collage.

Japan's handmade papers are the most highly prized. There are three main types: *Casey, gampi* and *mitsumata*.

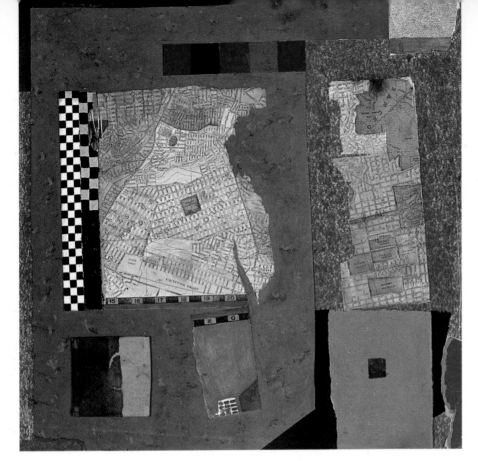

Casey is the strongest and has the longest fibers, which can clearly be seen in the paper. Gampi fibers, also long, are thinner and glossier, creating a tough, translucent paper. Mitsumata is composed of short fibers harvested from the bark of a shrub; it offers a soft, semigloss surface. Both gampi and mitsumata papers are naturally insect resistant.

Other Asian countries produce high-quality handmade paper. In the Philippines, the leaf fiber abaca and grass fibers such as bamboo, rice, and rattan are sources for paper-making. A long tradition of Himalayan papermaking exists, employing bast fibers taken from the inner bark of a tree commonly referred to as the "paper tree."

▲ **Eloise Pickard-Smith**
Little Old Ladies Home
Paper and fabric with found objects
18.75" x 18.25" (48 cm x 46 cm)

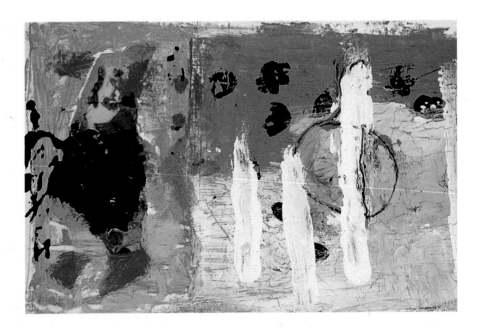

▶ **Susan Gartrell**
Blackbird
Paper with mixed media
4.5" x 9.25" (11 cm x 24 cm)

Photo by Kay Canavino

Its fibers can be harvested without killing the plant, an important benefit in the environmentally endangered Himalayan forests. In India, handmade paper is produced from a variety of fibers—khadi (a long-fiber cotton), recycled jute sacking (gunny paper), sugarcane fiber, banana leaf fiber, rice husks, and tea, algae, and wool fibers.

Certain features of a paper should be weighed when considering it for a particular use in collage. A paper's texture (determined by its fibers), its thickness (resulting from how heavily the pulp was applied to the screen), and its shape and size (determined by the size of the screen or how the paper was cut) will influence an artist's choices. Thick, opaque machine-made papers might form a collage's base; translucent, delicate papers can be layered on the surface. Medium-weight papers can serve many purposes because they are thin enough to fold easily, yet thick enough to hold their position and shape.

In collage, the artist can celebrate paper's richness as an expressive medium, whether working with comic strips, wallpaper, dress patterns, catalogs, sheet music, stamps, poster board, maps, ruled notebook paper, playing cards, playbills, or handmade art papers. Exploring a variety of papers and their special characteristics and possibilities is one of the pleasures of collage work.

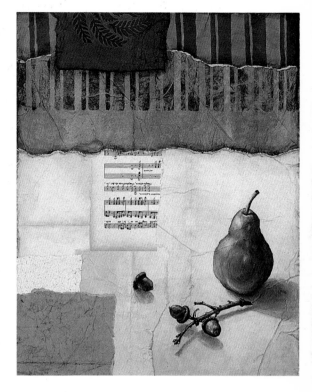

▲ **Rachel Paxton**
Between Noon and Sunset #22
Paper with mixed media
19" x 15" (48 cm x 38 cm)

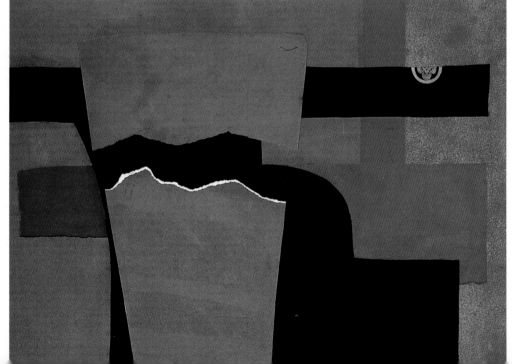

◄ **Eloise Pickard Smith**
Vessel
17.5" x 24.5" (45 cm x 62 cm)

Paper
TECHNIQUES

To begin a paper collage you will need some basic

supplies; for cutting, you will need scissors, a safety ruler, knife blades in a variety of sizes, and a cutting mat. Cutting mats are usually made of firm rubber that grips the paper, ensuring control as you cut and providing a clean edge. You also must choose the best glue for your project. Rubber cement minimizes rippling and puckering, but be careful—its bond is not permanent, and papers applied with it can be peeled off. Other possibilities include PVA glues such as Elmer's Glue-All and Sobo Premium Craft & Fabric Glue; you might also use a glue stick. Acrylic gel affixes papers well and is transparent when it dries. Each glue suits different tasks and thicknesses of paper; in fact, a combination of different glues might be used in a single project. Before assembling your collage, experiment with scrap papers to determine which glue works best with your materials.

Next, take out the collage materials you have gathered: family pictures, postcards, craft paper, envelopes with postmarked stamps, old magazines from the attic, gift bags, construction paper, specialty papers, old birthday cards, crossword puzzles, and so on. Find a large, clean surface on which to work, and cover it with newsprint or brown paper to protect it from glue. Place the "background" sheet of paper on this surface. It is usually best for the novice to begin with a small sheet.

Next, choose one piece to form the focus of the work. Consider its text or image, its texture, and its color. Before you do any gluing, choose the rest of the pieces and rearrange the papers until you are satisfied with the result. Some collage artists prefer to cut collage pieces in a pattern. Use newsprint or brown paper to create a template, and then lightly trace the pattern onto the collage papers.

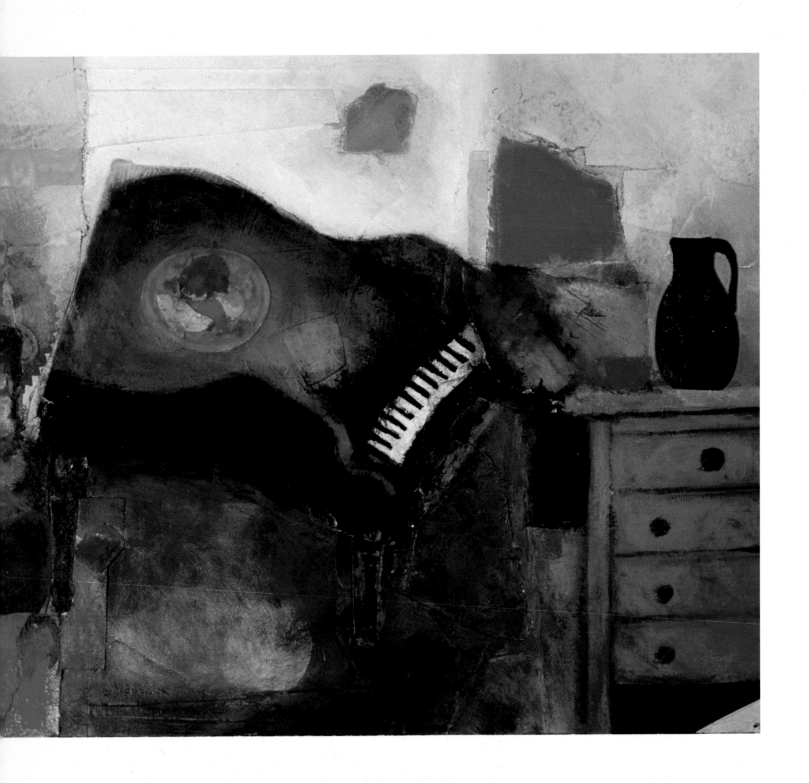

To avoid pencil lines on the front of the collage, trace the pattern on the back of each paper, but be sure to place the pattern piece facedown as well, to ensure the correct result. Then carefully cut out the collage pieces.

You can manipulate the paper pieces in various ways before affixing them to the collage surface. Cutting paper produces a clean edge; use a narrow, pointed knife blade on delicate papers and a razor blade or X-Acto knife on thicker papers, such as poster board. Folding paper creates a softer straight edge, with some relief. Tearing paper, unless you use a ruler, will not result in a straight edge but produces a random, spontaneous feeling. Paper can also be crumpled, punctured, wetted, or decorated with paints, color pencils, block prints, and so on.

Get ready to glue the pieces into place after you are pleased with the overall composition of the collage and the shape, texture, and decoration of each piece. Keep a damp cloth or paper towel ready, to wipe excess glue off your hands as you work. Plan before you begin; it might be best to affix the larger background pieces first, and then add the details. Or you may wish to assemble complicated elements of the design, such as a flower with petals made of different papers, before securing them to the collage.

Coat one of your collage pieces evenly and sparingly with glue. A brush will be useful if you are using a runny glue. Then apply it smoothly to the collage, using gentle pressure with the heel of your hand. You might place a cloth or paper between your hand and the collage, to keep the surface clean. Carefully follow this process with each piece, and the collage will take shape neatly before your eyes. Let the piece dry completely before adding the finishing touches—a bit of painted or penciled color, another paper detail or two, a light acrylic wash, or whatever your work of art inspires you to do.

▲ **Susan Gartrell**
Easter Island
Paper with mixed media
5" x 6.5" (13 cm x 17 cm)

◄ **Timothy Harney**
The Piano Room
Paper with acrylic and mixed media
13.75" x 16.75" (35 cm x 43 cm)
Courtesy of the artist and Clark Gallery

► **Robin Chandler**
Genesis, Genesis
Paper collage
38" x 48" (86 cm x 122 cm)
Photo by Kay Canavino

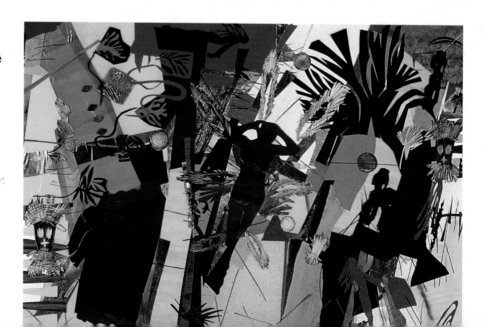

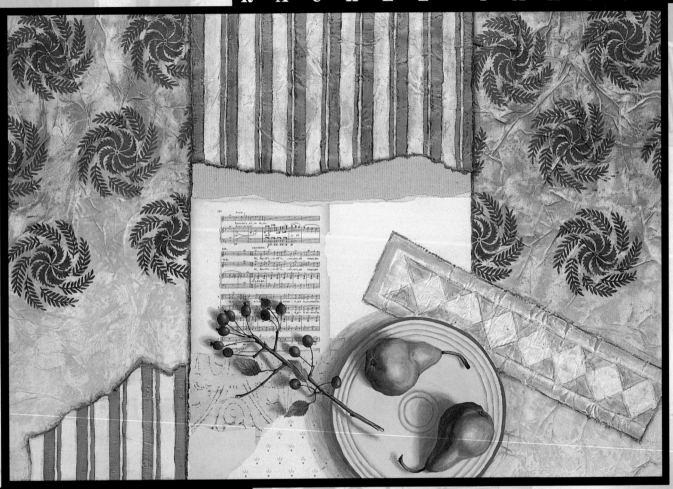

RACHEL PAXTON

TROMPE L'OEIL
Paper Collage

Pattern and the relationship between art, nature,

and spirituality have been the focus of Rachel Paxton's work for the past 15 years. Her paper collages address life, death, and the passage of time, and they project a calm, contemplative atmosphere. They also reflect her allegiance to a time when humanity held greater respect for nature, craft, and religion.

Although Paxton once constructed painted abstract assemblages (three-dimensional collages) made from found objects and wood, she now concentrates on collages that are composed of paper only. Still, her background as a trained textile designer is evident in her work. She creates small paintings that simulate specific types of fabrics—striped mattress ticking and nineteenth-century wallpaper designs inspired by William Morris, for example—and affixes them to her collages. Her ability as a painter shows in the carefully rendered details. By using block prints of certain designs rather than hand-rendering them, she creates a consistent pattern. She prints her designs on beige or gray Arches paper or on tissue paper, to

which she later adds texture by crumpling or painting.

In her most recent work, Paxton has examined the passage of time by using fruit still life as a metaphor for the cycle of human life. She uses a number of techniques to evoke the passage of time. Coffee-dyeing gives an aged quality to certain papers; she simply soaks the paper in coffee for a few minutes and then lets it dry naturally. The result is much like "foxing," the browning effect produced by the aging process in papers that contain wood acid. Since foxing typically affects older paper, this type of staining is recognized as antique. Elements such as old sheet music and faux vintage fabric lend an air of antiquity to her collages. For the viewer, these familiar objects from the past evoke memories and create a feeling of nostalgia.

Paxton also tries to produce a sense of altered space in her collages. Although the background of her work is flat, Paxton introduces shadowing in the fruit still life to disorient the viewer, who seems to be positioned both within and above the collage. This juxtaposition expresses the discomfiting relationship between the past and the present, as well as the shifting nature of human perception.

◀ *Pinwheel Chamber, Late Afternoon*
Paper with mixed media
32" x 40" (81 cm x 102 cm)

MATERIALS

acrylic paints in a variety of colors

assorted specialty papers

containers for mixing

easel

matte acrylic gel

newsprint

number 2 pencils

paintbrushes

palette knife

paper palette

paper towels

printmaking paper (such as Arches) in buff

scissors or other cutting tools

spotlight

water and paint containers to mix in

I n preparing to create a paper collage, the artist chooses from her stores of gravestone rubbings, old sheet music, tracings of wallpaper, block prints with motifs adapted from fabric designs, and coffee-dyed nautical maps.

 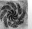 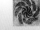

Tinting Paper

In addition to tinting paper with coffee, you can try other liquids to produce a variety of hues. Green tea produces a nice effect.

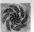 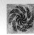

1 For the preliminary design, Paxton lays out the paper painted with a mattress ticking pattern, sheet music, and crumpled tissue printed with repeating pattern motifs. She tears and cuts the original sheets to create textural interest and a balanced composition. She then fine-tunes the composition by cutting or tearing small bits of paper and by rearranging and adding pieces.

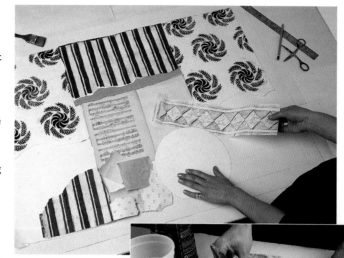

2 Paxton glues the bottom layer into place first; she turns the torn paper over onto a pile of clean newsprint, which keeps the edges of the collage free of excess glue. She then applies acrylic gel with a 1 1/2-inch brush, using strokes that radiate from the center of the paper to the edges, covering the paper completely. Paxton then places the piece onto the collage and makes it adhere smoothly by applying even pressure with the heel of her hand. Placing a piece of clean tissue paper over the freshly glued paper before pressure is applied will keep the surface clean. After all the papers have been glued into place, the collage is allowed to dry completely.

3 Next, Paxton applies acrylic gel to portions of the crumpled rice paper, which was glued over the block print pattern for textural interest. After it dries, the acrylic gel resists the light acrylic wash that she is shown brushing over the surface, thus leaving some areas untinted. This subtle coloring heightens the textured effect of the crumpled paper.

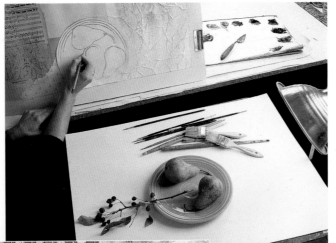

4 At this point, a difficult stage of the process begins—the addition of the painted still life. Paxton determines the position of the fruit on the plate and the placement of shadows by looking at the still life from above, under direct light. Once the composition of the still life and its placement have been decided, the artist sketches it directly onto the collage, using a number 2 pencil.

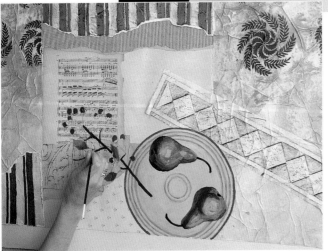

5 The artist now begins to paint the still life onto the collage with acrylic paint, which is easily mixed and water soluble. She begins this process only after the acrylic gel and subsequent washes have dried completely.

Making a Deckle Edge
To create the look of a deck-led edge, use a ruler when tearing the paper pieces. This ensures a straight edge but produces a soft effect.

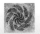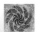

Texture Tip

If you plan to crumple a piece of paper, cut it slightly larger (by $\frac{1}{8}$ inch to $\frac{1}{4}$ inch) than the area it is intended to cover, to allow for shrinkage after crumpling.

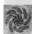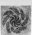

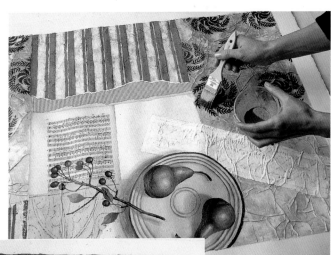

6 Once the still life is completed, Paxton goes back into the collage to balance the overall effect by adding paper or adjusting painted areas with small amounts of color.

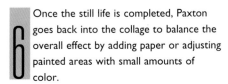

7 In the final step of the process, the artist adds depth and an aged effect by enhancing the torn and deckled edges of the paper with a light brown acrylic wash. The completed collage is a product of tearing, gluing, painting, and balancing.

KAREN L. McCARTHY

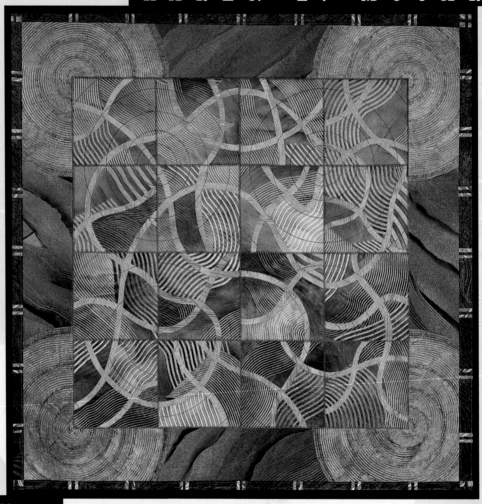

WOVEN
Paper Collage

Karen L. McCarthy's paper collages express

her exploration of the tension between clarity, order, and specificity, on one hand, and the ambiguity of abstract forms. She seeks to convey spatial depth through rich surface texture. She finds that paper as a medium lends spontaneity to her work, enabling her to rework surfaces, to build up media, and to add depth.

American quilts, Japanese landscape design, and the undulating pathways that pattern many board games have influenced McCarthy's work. Most recently, she has focused on American artists and writers of the nineteenth and twentieth centuries; several of her collages pay homage to particular individuals whom she finds intriguing or inspiring. Her designs mix sinuous lines with repetitive, structured patterns. McCarthy's distinctive use of paste

paper, a textured paper that she creates herself by applying homemade, dyed cornstarch paste to papers, imbues her collages with a multiplicity of pattern and color.

In the piece entitled *Pushing Up New Roots: For Edith Wharton*, McCarthy reflects upon Wharton's concerns about intellectual growth and repression in turn-of-the-century American society. The title refers to a letter that Wharton wrote to Bernard Berenson, in which she questioned the ability of human beings to "push up new roots." The work is alive with movement, suggesting that growth comes at the cost of pushing through barriers and grappling with conflict.

◀ *Pushing Up New Roots:*
For Edith Wharton
Paper with pigmented cornstarch, thread, and colored pencil
26" x 26" (66 cm x 66 cm)

MATERIALS

acrylic and metallic paints

colored pencils

compass

cornstarch paste (see recipe on page 35)

fabric paint

graphite tracing paper

number 2 pencils

paintbrush (1-inch flat)

papers for making paste paper

printmaking paper for backing

ruler

scissors or other cutting tools

Scotch Magic Tape

sewing machine (domestic or industrial model)

thread

white PVA glue (such as Sobo Premium Craft & Fabric Glue)

Paste and Paper

Many papers work well as a base for paste paper; even handmade papers will do the job, but they must be handled carefully or they will rip. Printmaking papers sometimes absorb too much moisture from the paste, yet they are very nice for reworking with lead or colored pencils. Try a variety of papers to find which you prefer. A list of suggestions follows:

Arches

Canson Mi-Teintes (in colors and in white)

Rives

Strathmore Bristol (in 1-ply kid finish)

Strathmore Charcoal (in colors and in white)

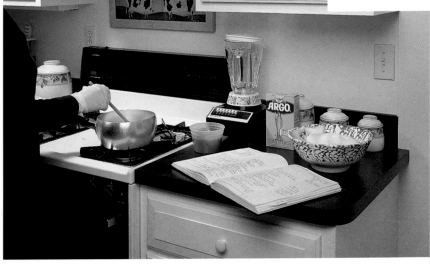

blender

cooking pot

cornstarch (1 cup)

disposable plastic cups

**liquid pigments
(such as Guerra)**

plastic spoons

rubber gloves

stove or hot plate

strainer

water

McCarthy uses a traditional method of making pigmented cornstarch paste. She adds cornstarch to a pot of boiling water, stirs constantly until it thickens, and then lets it cool to a gel. Then she colors the paste with liquid pigments.

KAREN L. McCARTHY'S CORNSTARCH PASTE RECIPE

Dissolve 1 cup of cornstarch into 1 cup of room-temperature water. Place the mixture in a pot, and heat it slowly. Gradually add 3 more cups of water to the mixture, and continue heating, stirring constantly, until the mixture boils. (Caution: bubbles may pop messily; be careful!) While stirring, boil the mixture for 2 to 3 minutes, until it is thick and forms a gel. Let it cool completely.

Remove 1 cup of the mixture, and place it in a blender. Add 1 cup of water, and blend it until smooth; this makes a thin paste. Add less water if you would like a thicker paste for a particular project. Strain the paste before using it.

To add color, simply use a plastic spoon to stir paints or pigments into cups of paste. Never place pigmented paste into a blender that will be used for food preparation. Pigments stain easily and should be handled with care (wear rubber gloves). The paste will keep for several days if stored in the refrigerator or another cool place.

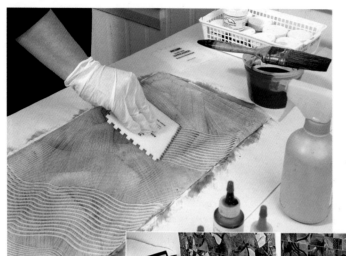

 McCarthy brushes the cornstarch mixture onto the paper with a paintbrush, taking care to cover the surface completely. She makes patterns and textures on the surface with implements such as combs and cookie cutters, to add shadows, depth, and rhythm. She then allows the paper to dry completely. A second layer of color can be applied after the first one dries. Colors will lighten somewhat as they dry. The artist often spends a week at a time on this process, making enough pigment-dyed papers to last for a couple of months.

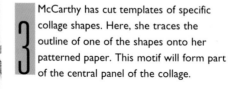

With a variety of colored, patterned papers at hand, McCarthy is ready to begin a collage. First, she sketches a full-scale design onto newsprint and selects papers from her well-organized collection.

McCarthy has cut templates of specific collage shapes. Here, she traces the outline of one of the shapes onto her patterned paper. This motif will form part of the central panel of the collage.

4 After cutting out all the shapes, McCarthy adds shading and texture to their surfaces by reworking them with a variety of materials: fabric paint, paste, colored pencils, and acrylic and metallic paints.

5 At this stage, McCarthy glues the smallest collage pieces onto the larger squares. Although she has precisely drawn the collage's overall design, she often assembles the entire collage (using a bit of removable cellophane tape folded over and applied to the back of each piece) before beginning to glue the pieces together. Thus she can fine-tune her design as a visual whole and ensure the proper positioning of each piece.

6 Next, the artist considers where she will apply stitching to the collage. Then she assembles one section at a time, gluing the pieces on a paper backing cut to fit. After the glue has dried, she draws lines that will guide her stitching, using a pencil with a ruler or compass.

7 McCarthy stitches along the penciled lines. Working with small sections of the collage simplifies the machine sewing. She has already tested samples of the papers to determine proper needle size and tension—a step she considers absolutely essential. Needles that are too small may break; McCarthy often uses Schmetz jeans/denim number 16 needles for work with thick papers.

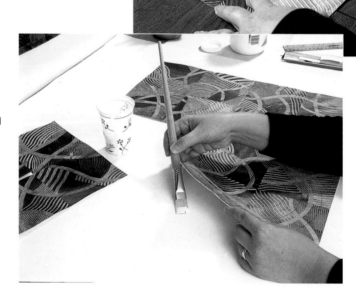

8 Once all the sections of the central panel are complete, McCarthy attaches them to the full-scale paper backing of the collage. She applies white PVA glue with a 1-inch brush, to make an even, spare application.

Stitch Tip

You might use hand stitching rather than machine stitching to embellish paper, for both practical and aesthetic reasons. Machine stitching can be awkward for larger works; hand stitching allows more freedom of choice in threads and yarn, and may yield a freer line. Hand stitching is, however, more time consuming.

9 Here the artist finishes the edges of the four central-panel squares with a zigzag stitch.

10 McCarthy next attaches the stitch-embellished border of the collage, using a minimal amount of glue. Individual pieces are weighted for drying, and to prevent wrinkling.

11 After the glued border has dried, McCarthy finishes the edge between the central panel and the border with a zigzag topstitch. Because the entire collage must be handled to complete this final step, great care must be taken not to bend or wrinkle the delicate papers. McCarthy's background in sewing serves her well here.

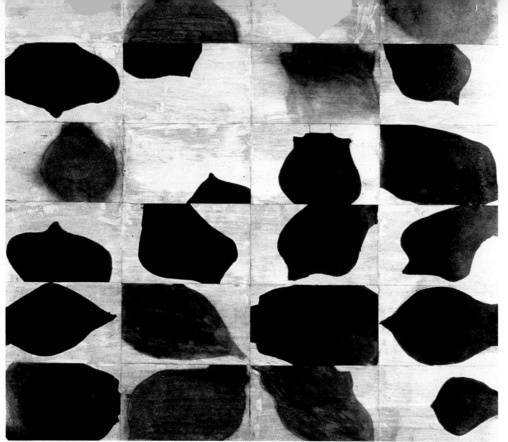

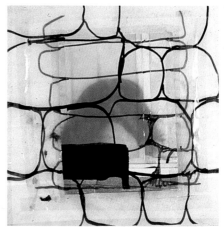

Gina Occhiogrosso
After Millay
Mixed media paper collage
18" x 20" (46 cm x 51 cm)

Gina Occhiogrosso
Untitled
Mixed media vellum collage
14" x 14" (36 cm x 36 cm)

Eloise Pickard Smith ▶
Hanaogi
22.5" x 30" (57 cm x 76.2 cm)

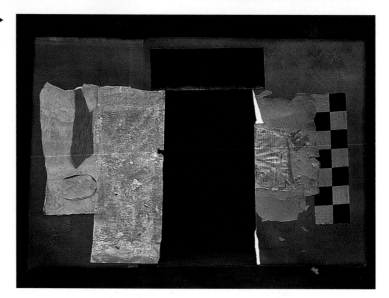

GALLERY

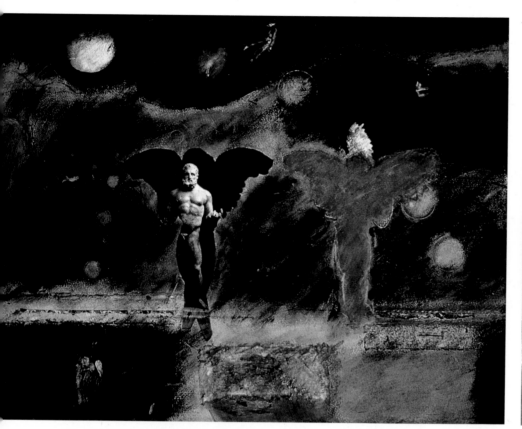

Felicia Belair-Rigdon
Untitled
Mixed media collage with handmade paper
30" x 39" (76 cm x 99 cm)

Felicia Belair-Rigdon ▲
From a Long Time Ago
Mixed media collage with handmade paper
24" x 32" (61 cm x 81 cm)

◀ **Susan Gartrell**
Woods Hill
Paper with mixed media
4" x 4" (10 cm x 10 cm)

Photo by Kay Canavino

▲ **Gordon Carlisle**
Lady of the Lake
Collage with acrylic painting enhancement
12" x 8.75" (30 cm x 22 cm)

▼ **Gordon Carlisle**
Repose
Collage with acrylic painting enhancement
3.5" x 5.5" (9 cm x 14 cm)

▲ **Karen McCarthy**
Moksha-Patamu: For Beatrice Wood
Paper with pigmented starch paste, thread, and colored pencil
26" x 26" (66 cm x 66 cm)

Rachel Paxton ▶
Pinwheels & Pears, Early Morning
Paper with mixed media
21" x 38" (53 cm x 97 cm)

▼ **Nancy Virbila**
Summer Sun
Paper with mixed media
20" x 16" (51 cm x 40 cm)

▲ **Nancy Virbila**
Porter's Woods
Paper with mixed media
20" x 24" (51 cm x 61 cm)

▼ **Robin Chandler**
The Lesser Peace #9
Paper collage
18" x 24" (46 cm x 61 cm)

▲ **Robin Chandler**
The Lesser Peace #6
Paper collage
18" x 24" (46 cm x 61 cm)

▲ **Susan Gartrell**
Catch of the Day
Paper with mixed media
3.5" x 9.25" (9 cm x 23 cm)

Photo by Kay Canavino

► **Timothy Harney**
Orange + Lemon
Paper with acrylic and mixed media
5.5" x 9.25" (14 cm x 23 cm)
Courtesy of artist and Clark Gallery

▼ **Timothy Harney**
Late August and an Orange Bowl
Paper with acrylic and mixed media
11.25" x 7" (29 cm x 18 cm)
Courtesy of artist and Clark Gallery

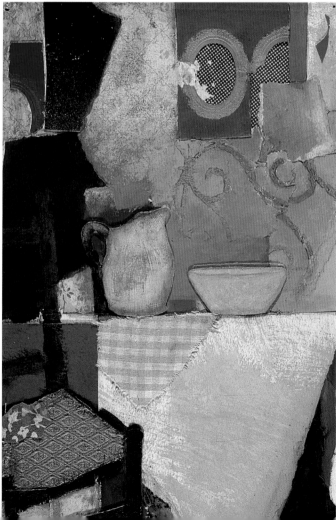

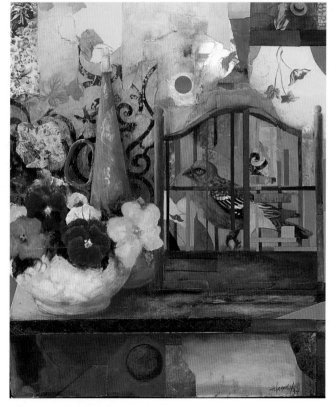

▲ **Timothy Harney**
Circus (Still Life for John Grillo)
Paper with acrylic and mixed media
22" x 18.25" (56 cm x 46 cm)
Courtesy of artist and Clark Gallery

Fabric
COLLAGE

In fabric collage, one piece of fabric is affixed to another either by gluing or by sewing. As in other forms of collage, the color, textures, and patterns of the materials make the end result interesting. Because glue does not secure fabric as permanently as sewing does, many artists choose to sew their collages together, which requires excellent sewing skills and makes the process more challenging. Materials for this medium are readily available: scraps from other sewing projects, remnants (especially decorator fabrics), vintage clothing, old tablecloths and linens (from antique stores, flea markets, or a grandparent's linen closet), upholstery fabric, and, of course, new fabric purchased off the bolt.

As a domestic art, sewing is intimately linked to women, and it is no coincidence that most fabric collage artists today are women.

Linda Perry
Approaching Storm
Fabric with found objects
40" x 57" (102 cm x 145 cm)
Photo by Joe Ofria

▲ **Dominie Nash**
Peculiar Poetry 9
44" x 44.5" (112 cm x 113 cm)

Fabric collage developed from the tradition of quilting, enriched by its emphasis on unifying diverse patterns and shapes, achieving excellence in stitchery, and gathering up seemingly insignificant fragments and scraps to rework them into a new functional and beautiful creation. The two disciplines are closely related and in fact overlap—much of the work of contemporary quilters incorporates elements of fabric collage, just as fabric collage artists have borrowed from the tradition of quilting. Some fabric collage artists began their creative work with fabric in the area of traditional quilting, whereas artists from other backgrounds have simply acquired solid sewing skills before delving into the medium of fabric collage.

Although fabric has been incorporated into other collage

disciplines (for example, Picasso and Braque employed it in their cubist collages), collage created primarily of fabric has developed more recently. It lends itself both to the production of functional pieces, such as pillow covers, handbags, apparel, and quilts, as well as to the creation of fine art.

Both of this chapter's featured artists, Clara Wainwright and Sandra Donabed, have a traditional sewing background; Donabed is also an experienced quilter. Both artists have moved away from traditional methods of working with cloth, taking a fresh look at their materials and stretching the boundaries of convention. Whimsical juxtapositions and an improvisational spirit make these works vibrant, thought provoking, and fun.

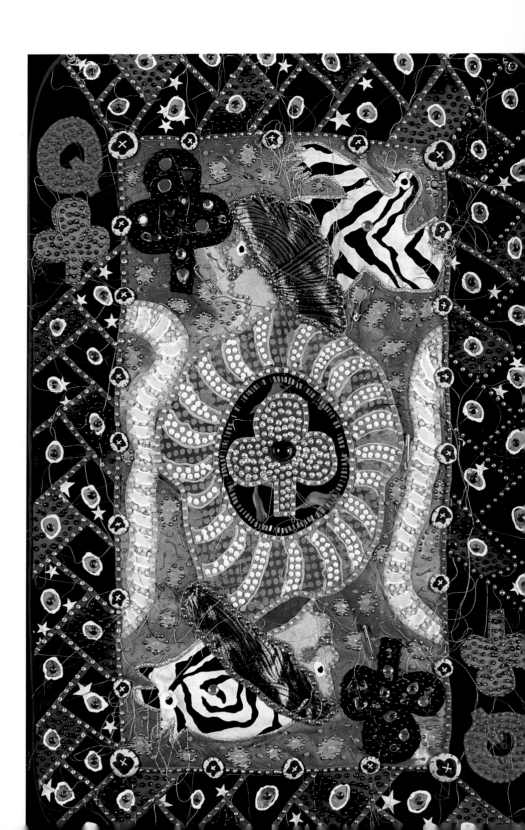

Therese May
Queen of Clubs
Embellished quilt
18" x 28" (46 cm x 71 cm)

Fabric
AND FIBER

Probably the best fabric choice for the beginning

collage artist is firmly woven cotton, such as broadcloth or muslin; you might choose solids, stripes, calico, gingham, or other patterns. But, though the rainbow of cotton yardage in a quilting shop may supply all an artist needs to begin, exploring other fibers and weaves really opens up the possibilities of working in this medium. Sheer organza (perhaps with iridescent fibers woven in), chenilles (woven from a plush yarn), drapey velvets, damask (a dense fabric with woven-in patterns), open-weave cottons that might be layered over another fabric, moirés (with a rippled watermark finish), netting, cottons woven with metallic threads, lace yardage, raw silk, terry cloth, different weights of linen, corduroy, shiny taffeta—the list of choices is endless. Studying the visual and tactile properties of various fabrics is an ongoing part of creating fabric collage.

In addition to the fabric store, popular sources of fabric for collage include the antique shop and flea market. Vintage materials from old dresses, doilies, embroidered handkerchiefs, neckties, banners, table linens, or laces can be sources of inspiration. You can also create an antique effect by using widely available fabric reproductions of old patterns, such as eighteenth-century block prints or art deco motifs. Think about recycling items from the attic as well, such as a swatch of your much-patched jeans from 1968 or a decal cut from an old T-shirt.

Decorator fabrics offer a trove of ideas for collage. Chintz, a cotton finished with sizing that imparts a sheen to it, is available in solids, prints (both tiny and baroque in scale), stripes, and plaids.

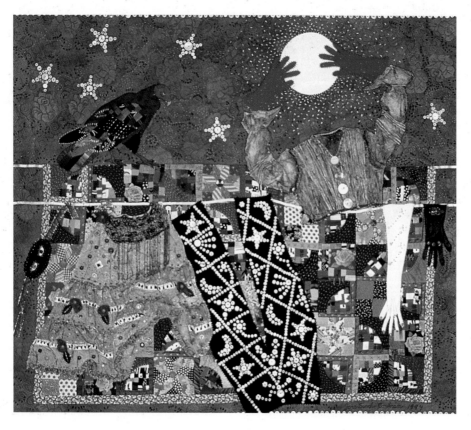

Though the sizing makes precise cutting simple, it will be lost if the chintz is laundered. Tapestry, a dense fabric often used in upholstery, is typically woven with intricate pictorial designs that might form the focus or background of a collage. Drapery fabrics, both heavy and sheer, present textures and patterns ranging from nubbly open-weave bouclés to heavy fabric printed with bright pop art designs.

Though most fabrics available today are machine-made, you might incorporate handmade or hand-decorated cloth to lend a unique touch to your work. The Asian traditions of *ikat* and *batik* are especially interesting. Ikat features mottled patterns that bleed into one another, an effect created by painting or tie-dyeing the threads of the warp or the weft—or both—before weaving. Batik fabric is patterned through wax-resist dyeing, typically yielding abstract, geometric, or floral designs. To add richness to your work, you might experiment with brilliantly dyed silks from India. Also, artisans in your local area might weave or dye specialty fabrics for you.

On the other end of the spectrum, fabrics that are considered strictly utilitarian can be appropriated for use in collage. Items as disparate as burlap feed bags, hair nets, a dishcloth, nylon stockings, quilt batting, cutouts from a sheet of vinyl, or a piece of a canvas sneaker might suit a particular topic or theme you'd like to explore—or inject a note of humor.

If you choose to sew your collage, the stitching can form a hidden part of the work's structure or may take a

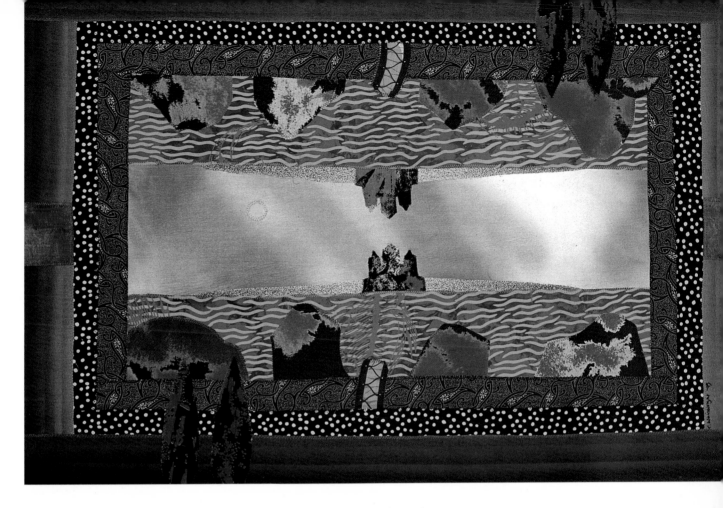

more prominent role. For displayed stitching, your choice of thread or yarn becomes an important part of the design process. Standard cotton, polyester, and silk machine-sewing threads might suit a project, but other possibilities should also be considered: metallic threads, shiny mercerized cotton, matte cotton embroidery floss, or silk mono-filament for hand stitching extremely delicate vintage fabrics. Be sure to determine whether a thread is suitable for handwork or machine stitching, and use it accordingly.

Finally, sewing notions such as braid, bias tape, ribbon, piping, and other trimmings are readily available in fabric shops to enhance your collages.

Though you might come to favor a particular type of fabric, explore them all!

▲ **Clara Wainwright**
Icbal's Vision
29.5" x 43" (75 cm x 109 cm)

Fabric
TECHNIQUES

To begin a fabric collage, you will need some

basic tools and materials. Find a few pairs of sharp scissors, including a small pair for delicate fabrics and detail work, and a large pair for cutting broad areas and thicker pieces of fabric. Pinking shears might be used to create an interesting cut edge. An iron is also necessary because, unfortunately, most fabrics have a tendency to wrinkle! Also, stock up on needles, threads in a variety of colors, sewing pins, a linen tape measure, a ruler, some tailor's chalk, a selection of soft pencils, and some tracing paper.

Next, gather your hoard of fabrics, and create a design. At a minimum, you will need a sketch to follow as you work. For your first project you might choose an image to reproduce in collage, such as a poster or a drawing of your own. Select fabrics that correspond to the image's colors, shapes, or textures, such as yellow corduroy for wheat fields, green velour for fir trees, and shiny blue satin for the sky. Find a large piece of material for the background that might form part of the image or serve as a complementary border.

Next, cut out the individual shapes. You may use templates based on your design or work freehand. Treat fabric edges carefully; they can make the difference between a successful piece of work and a valiant but unsatisfactory effort. Edges of fabric can be finished in a number of ways: torn, cut, hemmed, bound, or topstitched. To tear a piece of fabric, make a small cut with sharp scissors, and then rip it gently. Cutting should be done carefully with scissors. Experiment with cutting or tearing a small swatch of your fabric to see whether the edge holds its shape or has a tendency to ravel; match your technique with the effect you want. Hemming makes a soft, finished edge with a bit of relief.

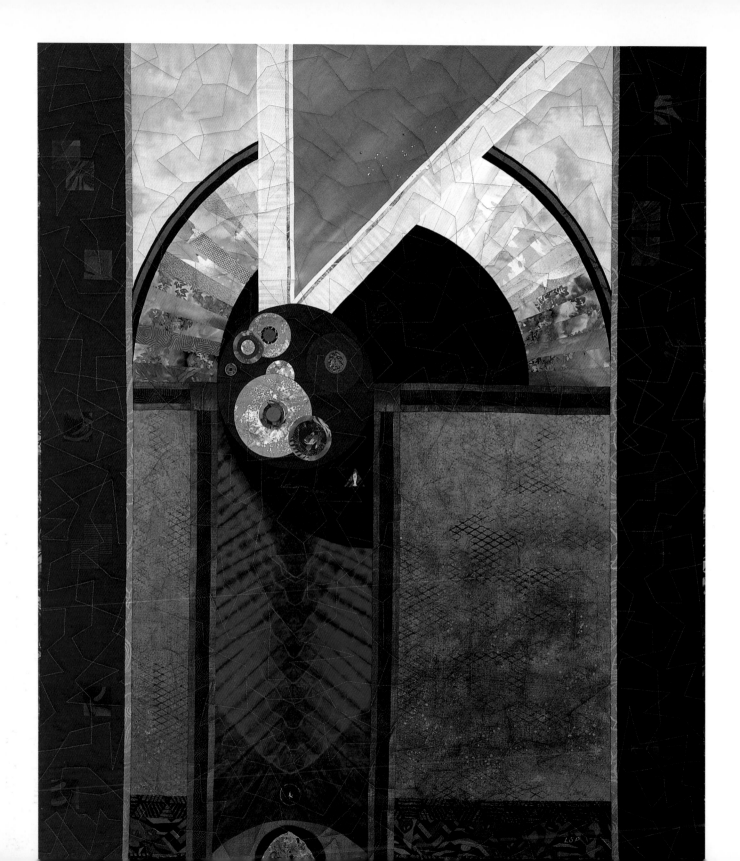

Binding—covering the edge with a separate piece of fabric—can be done in matching material or in a contrasting cloth. Like a hemmed edge, a bound edge offers a smooth finish with some relief. Topstitching secures edges neatly and helps to unify the elements of the collage.

You can embellish the individual pieces of your collage: Try fabric paint or embroidery; you may also stitch folds, tucks, or gathers into place. Extremely delicate items, such as a vintage fine lawn handkerchief, may need to be stitched carefully to a backing that will provide support.

The next step is to assemble all the pieces. Will you attach them to the background with glue or with sewing? If you choose sewing, decide whether to work by hand or by machine. You might use decorative embroidery stitches, such as chain stitch or feather stitch, to join the pieces. A machine zigzag stitch can connect the pieces while providing a neat edge that helps define each piece. Or you may prefer to keep the sewing invisible by seaming the pieces together with right sides facing each other (this works best with shapes bounded by lines, such as squares and rectangles; it is much trickier with curved shapes). Leave a ¹/₂-inch

seam allowance when you cut the pieces, if you plan to use this technique (you can trim it after sewing).

If you intend to use glue, you might select Glue Stic, aerosol glue, Sobo Premium Craft & Fabric Glue, or heat-activated adhesives such as Stitch Witchery. Test the glues on scraps of your materials to determine which types work best and how much you should apply. A thick application of glue might cause discoloration of fine fabrics or puckering.

Also, decide on the order in which you'll attach the pieces to the background; you'll avoid some

headaches by thinking out a procedure in advance. You might stitch larger background pieces into place first and then apply the details by hand. Perhaps it would make more sense to complete small areas of the collage one at a time, joining these sections together as a final step.

After all the pieces have been secured, complete any finishing tasks, such as topstitching, quilting, backing the piece, or touching up details. All that remains is adding the border: perhaps a wide mitered "frame" of fabric, a narrow bound edge, or neatly turning the collage's edge to the back of the work and stitching it down to create a smooth, unadorned look.

▼ **Clara Wainwright**
Willendorf Inventory #1
Fabric collage
16" x 25" (41 cm x 64 cm)

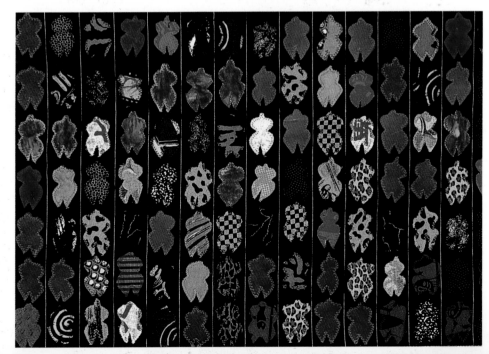

◄ **Linda S. Perry**
Land, Sea and Sky
Fabric collage
60" x 48" (152 cm x 122 cm)
Photo by Joe Ofría

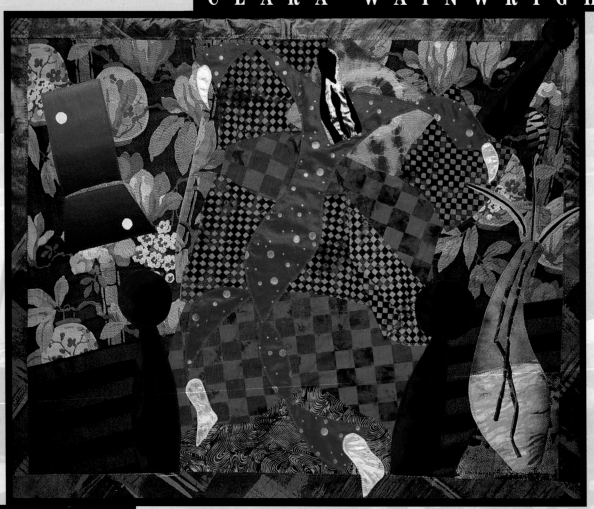

CLARA WAINWRIGHT

STORIES
in Stitches

Clara Wainwright uses fabric and sewing to

express her concerns about the fabric of society, especially the problems of famine, disease, and violence. She lifts these issues into the realm of art, where they can be considered philosophically and, she hopes, where insights might surface that could ultimately generate solutions. Despite the daunting issues she chooses to tackle, her work is instilled with a sense of hopefulness about life, particularly concerning women's ability to make the best of circumstances and to find beauty and joy in a confusing, conflicted world.

Wainwright's work is lyrical, combining fluidity of movement with arresting images. The exhilarating colors and liveliness of her collages reflect the influence of her favorite artists, Henri Matisse and Paul Gauguin. She also has been inspired by the humorous work of Paul Klee and the fantastic paintings of the sixteenth-century Dutch artist Hieronymus Bosch. She works intuitively, without detailed sketches or plans, and combines fabrics that vary in weight, texture, and color.

Wainwright began working in fabric collage with little formal training in art or design. But she knew how to sew, which gave her the confidence to plunge in. Her work encompasses diminutive pieces of an intimate scale, such as small pillows, and expansive creations, such as community quilts constructed in cooperation with adults and children. Her commitment to making a better world is evident both in the projects she takes on and in her fabric collages themselves, which acknowledge conflict and pain while projecting a buoyant hope.

◀ *Matisse Slept Here II*
Fabric collage
36" x 54" (91 cm x 137 cm)

MATERIALS

assorted fabrics

assorted threads to match or complement fabrics

fusible fabric adhesive (such as Stitch Witchery)

glue (such as Sobo Premium Craft & Fabric Glue, Elmer's Glue-All, or Glue Stic)

pins

quilted material for the backing of the collage

scissors

sewing machine (industrial or domestic model)

spray shoe polish

steam iron

Wainwright begins a fabric collage by browsing through her vast store of fabrics (she has been a collector for 20 years), much of it given to her by friends all over the world. Sometimes an image in a piece of material catches her eye and inspires an idea for a collage. Other designs and subject matter are inspired by the textures and patterns in various cloths.

1 Wainwright lays down the background fabric for the collage. Next, she cuts specific images and shapes from other pieces of material, arranging them on the background. She boldly combines stripes, checks, florals, solids, and abstract fabrics, balancing those that reflect light with others that absorb it. Here, she cuts an iridescent fabric with velvet stripes, which will serve as the hair of the figure in the collage.

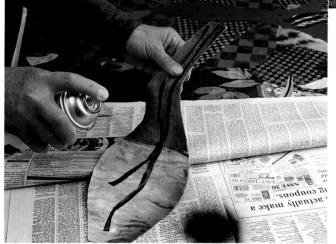

2 Next, the artist applies black spray shoe polish to impart shading and dimension to a piece of fabric that will represent a vase.

Fabric and Art
As a subject for fabric collage, you might choose to reproduce a favorite work of art, simplifying its shapes, colors, and lines.

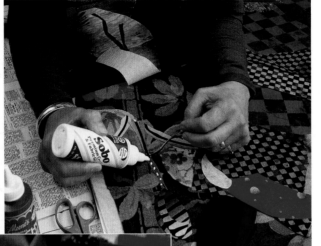

3 Wainwright dots white glue on a piece of fabric, using the smallest possible amount. She will let it dry a bit until it is tacky but not runny, before applying the piece; thus, the glue will secure the piece without seeping through the fabric to cause staining or rippling.

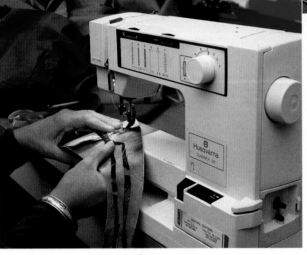

4 Wainwright now uses her sewing machine to stitch small details onto the larger pieces of the collage. All the details are sewn into place before the large pieces are joined.

Stitching Fragile Fabric

Certain fragile fabrics should be strengthened before being incorporated into a collage. You might use a fusible adhesive or a different fusible or stitch-applied backing to stabilize such pieces.

5 Wainwright applies a backing of fusible adhesive to a collage piece; when ironed, the adhesive will firmly adhere to the fabric. She will also use this adhesive to affix the large pieces of the collage to the background.

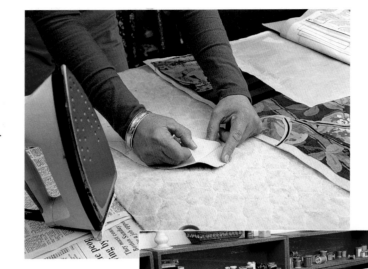

6 After all the components of the collage have been glued into place, the artist topstitches the pieces, completing the main panel of the work.

7 Wainwright adds stability to her fabric collages by attaching a ready-made quilted backing. She tacks it into place by hand with tiny, invisible stitches. To finish the piece, she attaches a decorative border.

SANDRA DONABED

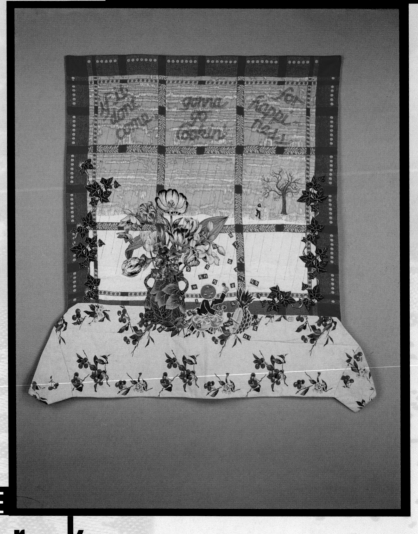

VINTAGE
Work

Sandra Donabed made doll clothes as a child

and her own clothes as a young woman. She took an interest in quilting in the early 1980s, eventually focusing on the nontraditional methods of contemporary quilting. Her first effort in that style, a quilt inspired by a kindergarten photograph of her son, won first prize in a local show. Donabed's quilts often feature vintage fabric that she finds at yard sales and flea markets. She has cut up costumes and vintage clothing to use in her work and often purchases bolts of discontinued fabrics and designer chintz samples.

Autobiographical themes inform much of Donabed's work, and she addresses feminist issues through the use of domestic objects and subject matter. *The Writing on the Window* portrays a spiritual journey in search of fulfillment, grounded in familiar, homey materials and leavened with a touch of humor. Transforming simple domestic objects to represent a fundamental human aspiration shows Donabed's respect for the realm of home—traditionally a woman's domain—yet she employs them as a metaphor for seeking a vision for the future, not as a cozy, secure cocoon. The quilt's text was inspired by the lyrics of a Bob Marley song: "If it don't come gonna go looking for happiness."

Donabed likens her quilt-making process to the automatic writing of the surrealist painter Yves Tanguy. She believes that the artist does not control an artwork, but rather that the work emerges from the subconscious if the artist will release and nurture it. Donabed enjoys the process of discovery involved in making her quilts and feels that her understanding of a piece and its significance in her life are deepened by each step in its creation.

The Writing on the Window
Vintage cloth and other materials
62" x 62" (157 cm x 157 cm)
Photo by David Caras

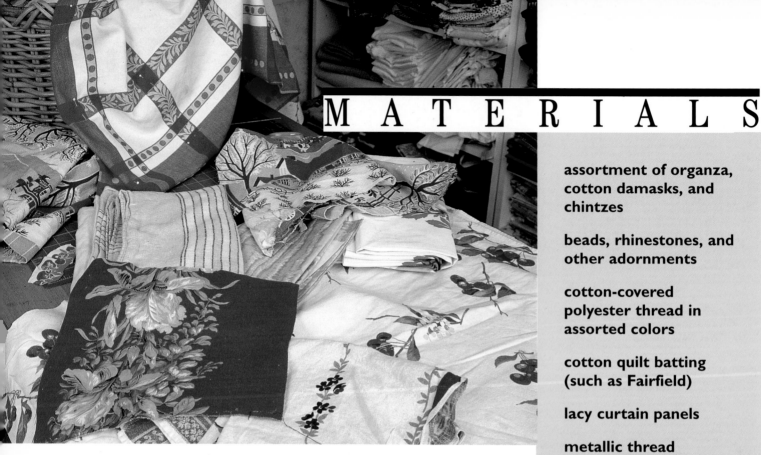

M A T E R I A L S

- assortment of organza, cotton damasks, and chintzes

- beads, rhinestones, and other adornments

- cotton-covered polyester thread in assorted colors

- cotton quilt batting (such as Fairfield)

- lacy curtain panels

- metallic thread

- moiré fabric for backing

- pins

- scissors

- sewing machines (both a domestic model and an industrial model for heavy work)

- tea towels

- vintage tablecloths

From her stash of vintage materials, Donabed chooses a large damask tablecloth to serve as the quilt's main design element—the grid of red bars resembles a window.

1 Donabed selects a number of complementary fabric samples and makes notes and sketches to explore ideas for her work. This part of the creative process will lead to a final drawing of the quilt.

2 The artist begins to construct the quilt by cutting the tablecloth fabric to form "windowpanes." She leaves enough of the white fabric to tuck under for a clean edge. A moiré fabric has been layered with an airy lace curtain panel to form the outdoor scene; sections of it are pinned into place within the windowpanes and then stitched.

3 Donabed often uses text in her quilts, which she creates by using a bias tape to form the letters. First she attaches the letters with pins and then sews them into place by hand. For this quilt she has chosen a fragile, bright blue organza for her lettering, cast in a graceful, longhand script.

4 Donabed has cut out large floral pieces from several fabrics to assemble this bouquet. She has attached these cutouts to one another with small areas of zigzag stitching; this secures the pieces so she can handle the bouquet as a single unit. She now pins the arrangement to a sheet of tissue paper to simplify moving it about on the background until she decides on its permanent position. After it is stitched into place, she will tear away the tissue paper.

5 Donabed uses a tight zigzag stitch to attach this cutout to the background fabric. Each element of the quilt is affixed in this fashion.

6 After finishing the assembly of all the quilt pieces, Donabed carefully pins together the layers of the quilt: the top, the batting that will serve as stuffing, and the moiré backing. In this painstaking process she ensures that the edges fit together perfectly and that the quilt is entirely smooth.

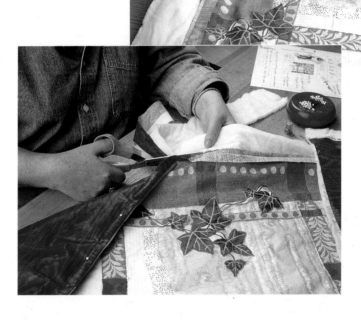

7 Donabed attaches 1-inch strips of the background material facedown on the edge of the front of the quilt. She then trims the batting and background material to the edge of the front of the quilt, and turns the 1-inch strip over, creating a hem on the reverse side of the piece. She stitches this down by hand, using a traditional hem stitch.

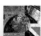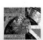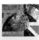

Making Bias Tape

You can make your own bias tape by choosing a lightweight fabric and cutting a length of it along the bias. Cut it about 1 inch wider than the desired width of the tape. Then tuck a ¹⁄₂-inch allowance under on each side, and iron the tape. Use the tape for lettering or other effects.

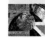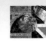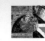

Linda Perry ▶
Tuscany
Art quilts
40" x 58" (102 cm x 147 cm)

Photo by Joe Ofría

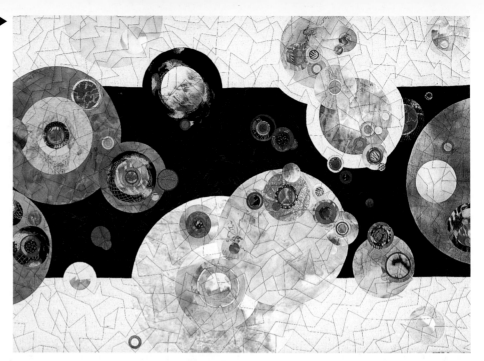

▼ **Linda Perry**
Faith and Time
Art quilts
42" x 48" (107 cm x 122 cm)

Photo by Joe Ofría

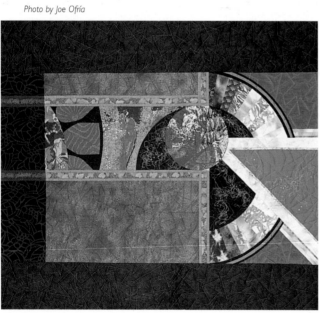

GALLERY

▲ **Dominie Nash**
Peculiar Poetry 8
43.5" x 42.5" (110 cm x 108 cm)

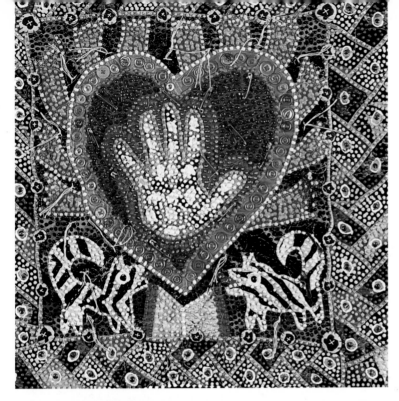

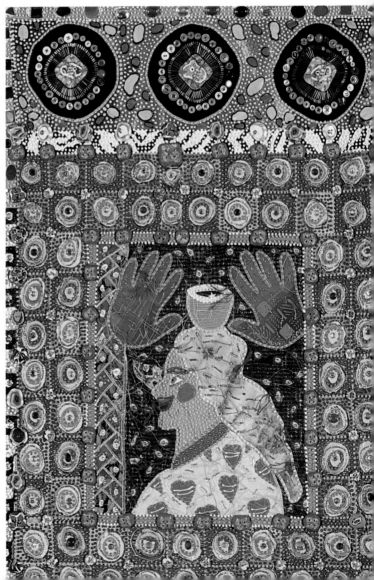

◄ **Therese May**
Hearts + Hands
Embellished quilt
20" x 20" (51 cm x 51 cm)

▼ **Therese May**
Child #6—Sandy
Embellished quilt
36" x 30" (91 cm x 76 cm)

▲ **Dominie Nash**
Sky Song 3
46" x 72" (117 cm x 183 cm)

Erika Carter ▶
Confinement
Art quilt
65" x 45" (165 cm x 114 cm)

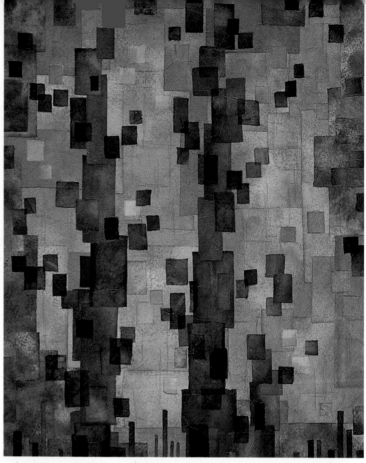

Erika Carter ▶
Reminiscent
Art quilt
60" x 44.5" (152 cm x 113 cm)

▲ **Barbara Mortenson**
Untitled
Fabric collage
3" x 5" (8 cm x 13 cm)

◀ **Barbara Mortenson**
Untitled
Fabric collage
3" x 5" (8 cm x 13 cm)

Sandra Donabed
Hearts + Gizzards
Quilt with fabric collage
72" x 78" (183 cm x 198 cm)
(detail right)
Photos by David Caras

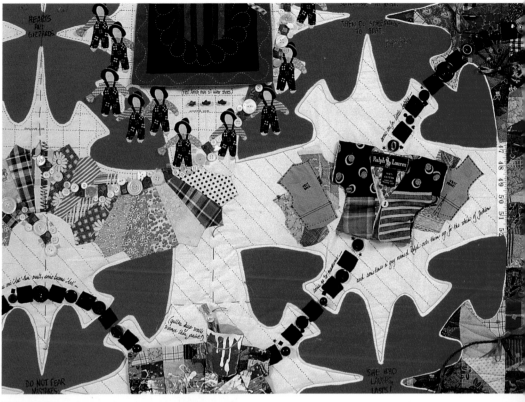

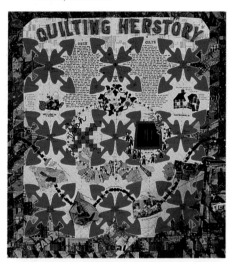

◄ **Barbara Mortenson**
Untitled
3" x 5" (8 cm x 13 cm)

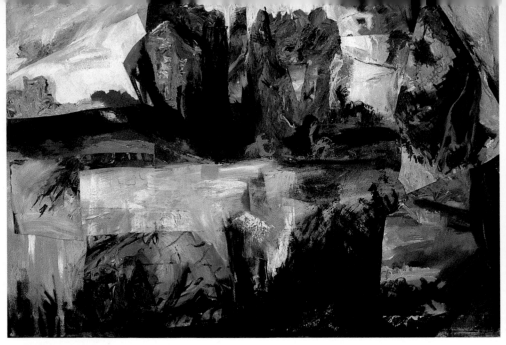

▲ **Carol Andrews**
Untitled
Fabric with oil and wax on canvas
27" x 38" (69 cm x 97 cm)

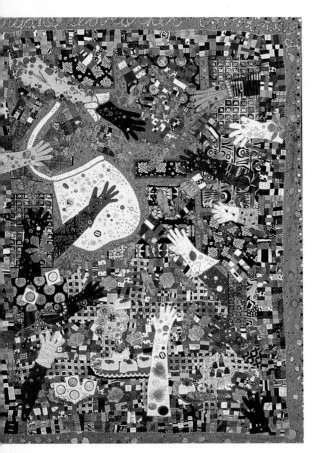

▲ **Jane Burch Cochran**
Devotion
Embellished art quilt
68" x 85" (713 cm x 216 cm)

Photos by Pam Monfort

Jane Burch Cochran ▶
Life Starts Out So Simple
Embellished art quilt
68" x 68" (173 cm x 173 cm)

Photos by Pam Monfort

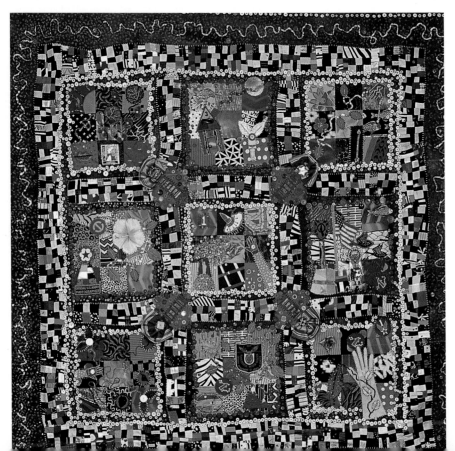

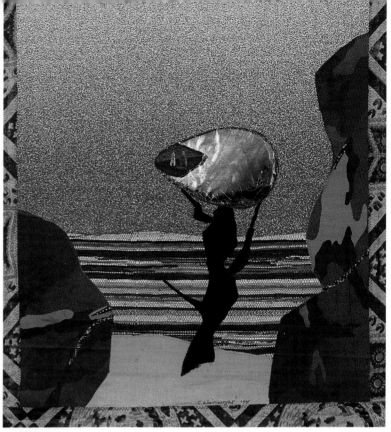

▲ **Carol Andrews**
Untitled
Fabric with watercolor, crayon, ink, latex,
and wrapping paper on canvas
23" x 30" (58 cm x 76 cm)

▲ **Clara Wainwright**
Waiting for Bosch
Fabric collage
26" x 22.5" (66 cm x 57 cm)

◀ **Clara Wainwright**
20th Anniversary Quilt for First Night
Fabric collage
100" x 77" (254 cm x 196 cm)

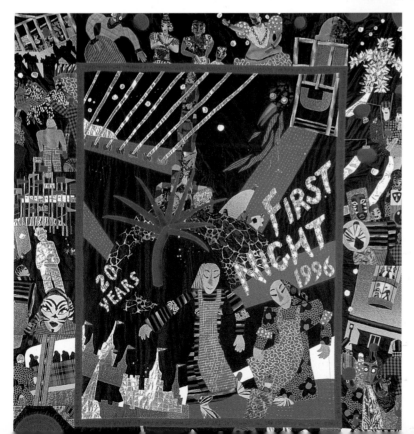

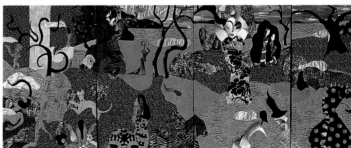

▲ **Clara Wainwright**
*Summer and Gauguin's Unanswered
Questions*
Fabric collage
48" x 108" (122 cm x 274 cm)

Collagraphy

Collagraphy, the process of making a print from a collage plate, has developed from traditional printmaking methods and the discipline of collage. Although a collage is assembled in the usual manner, it is not the end result; instead, the collage serves as a plate that transfers its textures, shapes, and lines (which must be expressed in relief) to a sheet of paper by means of a printing press. The end result is a two-dimensional work on paper.

The whole range of collage materials that impart texture and dimension—shoestrings, Mylar cutouts, textured fabrics, stalks of wheat, masking tape, scraps of lace, corrugated cardboard, twine, sandpaper, loofah fibers, lengths of macramé, leaves, sequins, tiny pebbles, paper doilies, feathers, crushed eggshells, twigs, and so on—may be affixed to a base (though certain techniques unique to this medium must be employed) to create the evocative juxtapositions and exploration of diverse materials and themes that characterize collage.

Robert Kelly
Kairos V
Collograph
39" x 32" (99 cm x 81 cm)

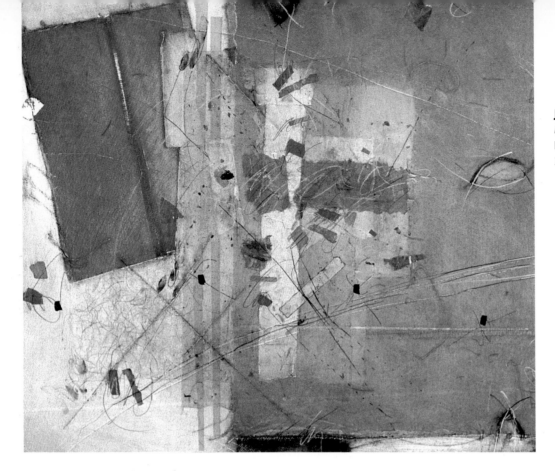

A plate and press can be used to produce a single image or a series of impressions of that image; however, in collagraphy it is sometimes difficult to produce a number of impressions from one plate, because some collage elements may become flattened or distorted after the first impression.

A collagraph's main elements include composition, color, and texture. Its composition is determined by the arrangement of collage elements; its colors result from the selection and application of printing inks or paints to the collage plate; its visual textures reflect those of the particular collage elements. Some artists embellish their prints with glued-on details such as bits of paper and artwork, threads, and wires; others enhance them with hand-rendered touches in paint, colored pencils, or other media.

Collagraphy requires more equipment than other forms of collage, but still constitutes an approachable and pleasantly

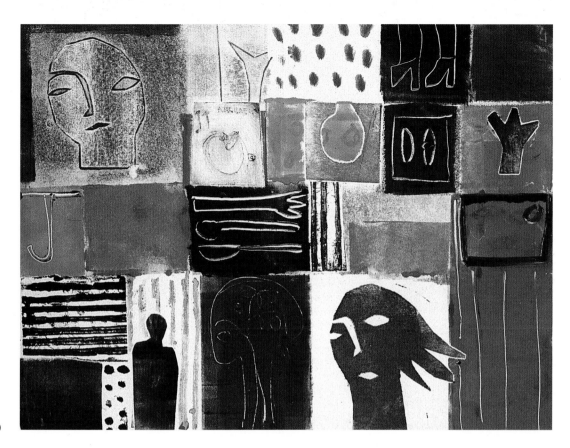

Deborah Putnoi
the J in my life
Monoprint
18" x 24" (46 cm x 61 cm)

experimental, improvisational way of creating art. Though primarily a fine art, collagraphy can also be used to create beautiful functional items such as greeting cards, book covers, posters, and illustrations.

Although both are printmakers, the two artists represented in this chapter differ in their approaches to creating collagraphs. Jennifer Berringer employs traditional printmaking techniques to execute her subtle, large-scale collagraphic images. Deborah Putnoi's approach is anything but traditional—her create-as-you-go style results in bold prints alive with spontaneity.

Collagraphy
MATERIALS

To create a collagraph, you will need special

materials and equipment, including a base, collage elements, glue, inks or paints, papers, brayers and brushes, and a printing press or other means to transfer the image from the collage plate to the paper.

First, select a base for the collage elements; the elements will be glued to it to form the plate. If a hand-printing technique will be used instead of a press, you have great freedom in choosing the base—corrugated cardboard, mat board, and even cardboard from shirt packaging are all suitable. If a press is to be used, you will need a much sturdier backing, such as Masonite, canvas board, a metal sheet, Plexiglas, linoleum, or plywood; the base's maximum thickness should be $1/8$ inch (it will be easier to run it through the press if its edges are beveled; you can sand the edges to achieve this). Also, consider the size of the press when deciding on the dimensions of the base.

Next, choose the elements of the collage. Remember that texture and raised (or recessed) patterns will be transferred to the print, but shapes that are not defined in relief will not show up. Also, an item's thickness and porosity must be considered. Elements that are thicker than $1/16$ of an inch will be difficult to print, though you might make an impression of a thick item, such as a jar cap or a door hinge, with modeling paste; it will pass more easily through a printing press and will create a faithful image of the original item. Porous items, such as fabrics and papers, must be treated to make them nonporous, or they will absorb ink and simply print a blurry splotch that lacks the definition and texture of the collage element. Applying a solution of acrylic medium and water will accomplish this.

To secure the collage elements onto the base, you will need a glue that both bonds well with a particular element and will remain strong yet flexible in the printing process. Acrylic gel and PVC glues such as Elmer's Glue-All and Sobo Premium Craft & Fabric Glue will affix cardboard, paper, and cloth successfully.

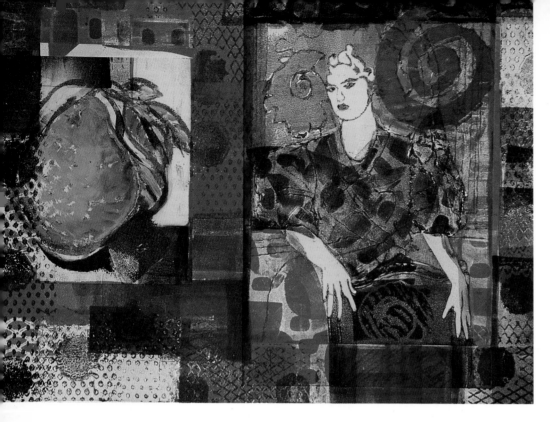

Emily Myerow
Pear Woman (Spring)
Monotype collage
14" x 18" (36 cm x 46 cm)

Rubber, metal, and wood need special fixatives such as epoxy resins, superglues, and wood glue.

Once the collage plate has been constructed, choose the ink or paint (oils, acrylics, and watercolors are all suitable). Each medium offers a different effect. Water-based paints and inks are easier to clean up because they do not require the use of a solvent. However, printing inks and oil paints offer greater permanence and reliability. (Although oil paints were once preferred over acrylics because of their quality of color, recent advances in the manufacture of acrylic paints have made this judgment obsolete.) Choose a paint or ink according to

the look you want for a particular collagraph. A given work can combine many colors or concentrate on a single hue.

Brayers (hand-held rollers used to apply the ink or paint to the collage plate) are made of hard or soft rubber, plastic, or gelatin, and they range in size from 1½ inches to 3 inches in diameter, and up to 2 feet in roller length (though for most projects, rollers of 4 to 6 inches in length will suffice). The hardness or softness of the roller will affect the application of color—a hard roller will coat only the uppermost surfaces of the collage plate, whereas a soft roller will push the ink into crevices and depressions. Some printmakers use

the end of a tightly rolled length of felt to daub color onto the plate; when the end becomes overused, it can be cut off, bringing fresh felt to the surface. Paintbrushes are not required in the printmaking process, but they can be helpful in applying details. You may also need to wipe excess ink from the plate—cheesecloth, newspaper, or a block of wood can be employed to create different effects.

Although several kinds of paper can be used to make a collagraph, printmaking papers such as Arches and Rives are the best choices. Manufactured specifically for printmaking, they are absorbent and resist tearing. In general, papers

Debra L. Arter
Flight Over
Collagraphy with *chine collé*
9.5" x 9.5" (24 cm x 24 cm)

with a high rag content will withstand the printing process well and won't discolor or disintegrate over time. Make sure to cut the paper with ample margins—they should be at least 2 inches larger than the plate at each side. The paper should also fit the press easily. Remember that the paper must usually be dampened before printing can begin.

If you do not have access to a press and wish to create a collagraph by hand, you will need a baren. This rubbing tool is a round disk, 5$\frac{1}{2}$ inches in diameter. Traditional barens are handmade of many layers of paper bound in bamboo in Japan, where they are used in making woodblock prints; less expensive manufactured models

are available in art supply stores.

The other option is to use an etching press to print your collagraph. The inked collage plate, covered with the printing paper and padded with felt printing blankets, is run between the press rollers at high pressure. The paper is thus pushed into the hollows of the plate to absorb ink and be imprinted with texture. The result is a completed collagraph, ready for drying and then displaying.

Collagraphy
TECHNIQUES

Once you have assembled the necessary materials

and equipment—a base, collage elements, glues, inks or paints, brayers, brushes, printing paper, and a printing press or barens—you can begin to compose your collagraph. Lay out the collage elements on the base, keeping in mind that the printed image will be reversed. If you have cut letters out of cardboard for text, for example, remember to apply them backward.

Before gluing any pieces into place, consider how the textures will transfer onto the print: a smooth element such as a Mylar sheet will not retain much ink on its surface after wiping, but ink will settle around its edges, thus defining its shape on the print; a string dipped into acrylic gel and placed on the base will create a line; partially raveled fabric (after it has been treated to make it nonporous) will print a fringed edge.

Choose collage elements that are not too thick; it is difficult to ensure a quality print when the paper has to be forced around items thicker than 1/16 inch. You may thin dense plant materials—cut flowers in half, or strip some of the leaves from a stalk (dried plant materials tend to hold their shape better; they must also be treated to make them nonporous). You may also make an impression of a thicker item, such as a key or an acorn—grease the item, coat one side with a paste or cement such as acrylic modeling paste, and then apply it to an absolutely flat sheet of paper (you might tape the paper down to ensure flatness as the paste dries). After several hours have passed, remove the item and cut off the excess paper. You may wish to use fine sandpaper to smooth the impression and reduce thick areas. Use the impression as you would any other collage element.

Next, treat any porous elements (paper, fabric, plant materials) to prevent them from absorbing ink. A thin application (on both sides) using a solution of water and acrylic medium will seal out moisture, allowing the surface to be coated with ink that will transfer its texture to the print. (Untreated material would absorb the ink like a sponge, printing an undefined blotch of color.) It is also possible to seal these elements after they have been glued to the base—just make sure the seal is complete.

Glue each collage element to the base, using glues that suit each material. You may also texture the base itself by cutting into it or by applying gesso or gels mixed with other materials (such as sand or crushed eggshells). After each element is glued into place, let the completed plate dry thoroughly. Clean off any nubs or thick streaks of glue or gel; otherwise they will show up on the print.

Next, prepare the colors. Though you may also use a brush or dauber to apply inks, a brayer is most typically used. Squeeze the colors onto a smooth palette, such as a Plexiglas sheet, to ensure that the brayer will be evenly coated. Tailor your choice of brayer and amount of ink to create the effect you desire. If you want all the surfaces of a built-up area to be inked, use a brayer with a soft roller and a liberal application of color. If you want only the topmost parts to print, use a brayer with a hard roller and less color. Textured surfaces that are left uncolored will emboss the paper as it rolls through the press; however, take care to protect these areas and other white spaces from trickles of ink. Wear cotton or plastic gloves to keep your hands clean.

For smooth, even color, inked areas should be wiped after the color is applied. Wiping with a cheesecloth produces a mottled effect that can help in blending colors. To effect a greater contrast between recessed and built-up sections of the plate, wipe with even strokes, using pieces of newsprint or even a block of wood; this removes ink from the top surfaces, yet leaves more in crevices and folds. You may need to repeat this process once or twice to distribute the ink or paint evenly. If, however, the color has been applied in a unique fashion, perhaps with brushes or in patterns not intended to cover a whole area, wiping may not be necessary.

Before printing, the paper must be cut to the correct size (leave at least a 2-inch margin on each side of the plate) and then dampened. This step removes sizing in the paper and softens it so that it can receive the imprint of the collage elements. Some papers must be soaked in a tray of water for a few hours; unsized papers may only need to be dipped quickly. Prepare the paper in advance, so that it is damp but not soaking wet at the time you will be ready to print. Handle the paper gently; it will be stronger after it has dried completely, but it can easily be torn when wet.

To prepare for printing, cover the inked plate with the paper, aligning it carefully so that there are even margins on each side (or you may prefer a wider margin on the bottom edge). Cover the paper with two or three felt printing blankets, which protect the paper as it passes through the press. You may wish to add foam padding to built-up areas on the plate to help it move smoothly through the press. It might be necessary to place a thin sheet of plastic between the paper and the blankets to protect them from glue or excess moisture. Then carefully run the print through the press. Some collagraph artists run a few proofs to fine-tune color, composition, and pressure.

You may instead use a baren to transfer the image to the paper. After placing the paper over the plate, rub the paper with the padded portion of the baren to obtain a smoothly transferred image. Using the edge of the baren will give a sharper outline. You can vary the pressure to create a range of effects.

Handle the completed print carefully. You may wish to touch up some details with color before drying the print. To dry it, sandwich it between several sheets of blotting paper, place these papers between sheets of newsprint, and then place all the papers between boards. Weight the boards with books or bricks, so that the print will dry flat, and replace the sheets of newsprint as they become wet. Keep the print weighted until it is entirely dry; then embellish it with lead or colored pencils, if you wish.

It is sometimes possible to create more than one print from a single collagraph plate. However, if the plate contains fragile items such as

plant materials and tissue papers, subsequent printings may be unsuccessful. Plates made of more durable materials may be re-inked immediately after the first print is pulled, and then printed again. If you would like to print at a later date, clean the plate carefully (use solvents if oil-based colors were used, and water for water-based colors). Make sure that the cleaning agent will not destroy the glue bond.

Because of the many variables involved in making collagraph prints, experimentation and experience play important roles in the process. Expect surprises! Read up on the subject, refine your technique, and then let inspiration guide you.

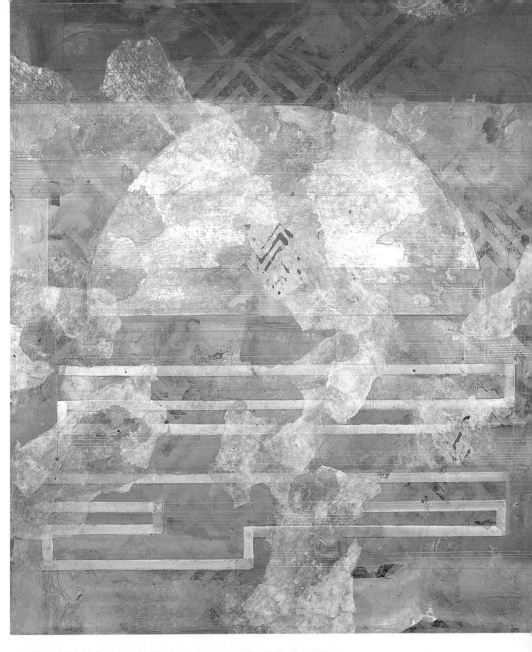

Robert Kelly
Ghanto XII
Collagraphy with mixed media
54" x 42" (137 cm x 107 cm)

Meryl Brater
The Belly of Stones
Collagraphy with drawing in mixed media book
(detail)

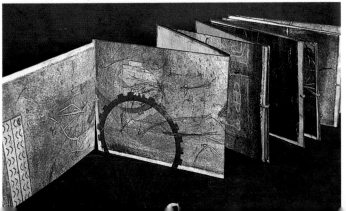

JENNIFER BERRINGER

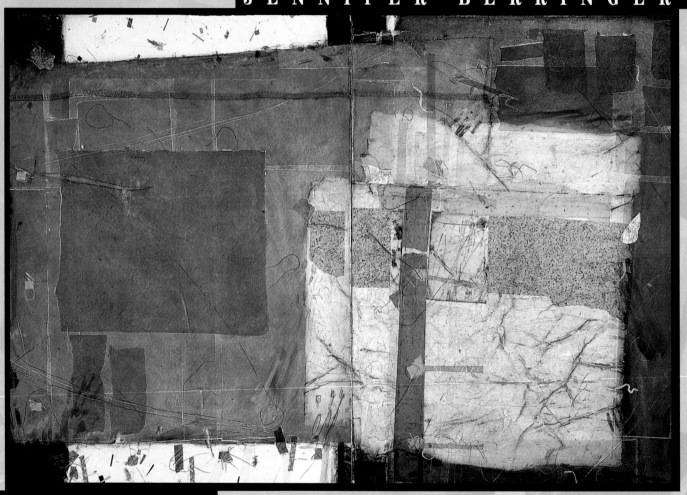

ACCIDENTAL Music

Jennifer Berringer's prints combine both formal

and organic elements in large-scale, expressive abstractions. The scale she works in has grown beyond the dimensions of her press, and she often assembles panels in diptychs and triptychs.

The square and rectangular shapes that predominate in her prints are punctuated with bits of glued paper, threads and strings, metal strips, sequins, and swatches of fabric. Together with the lines, squiggles, and spirals that she scratches into areas of ink, these details bring a sense of intimacy and animation to her work. As she builds up collage elements on the base, Berringer emphasizes the natural properties of paper—crinkled areas, torn edges, and layered effects subtly texture her prints. Her palette features muted tones of beige and gray, though she somtimes adds brighter colors for contrast.

Berringer employs traditional techniques in creating, sealing, and inking a plate for printing, but she is not interested in exercising complete control over the process: she enjoys the experimental aspect of the work, which she likens to laying down riffs in jazz. She often makes several proofs of a print, varying the application of ink (wiped smooth with cheesecloth or brushed on more heavily, for example) and the pressure of the press until she is satisfied with the result. Berringer appreciates the unpredictable nature of the medium, often finding that an unexpected effect enhances her work.

Dream Journal IV
Collagraph
62" x 82" (157 cm x 208 cm)

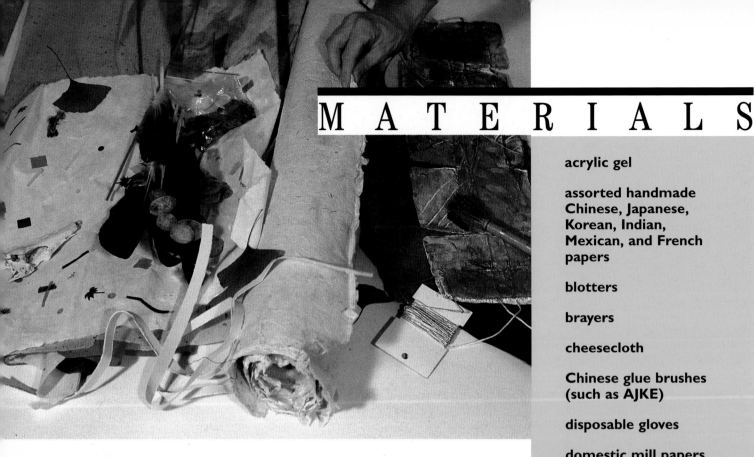

MATERIALS

The artist begins to plan her collagraphic plate by choosing from the materials she has collected: paper, scraps of wire and fabric, and leftover pieces of her artwork.

All That's Fit to Print

In addition to many kinds of paper (bits of sheet music, crepe paper, crumpled tissue), you may also affix ribbons, metal foil, and fabrics by placing them on the base facedown, with the glue side up. Small pieces work best.

acrylic gel

assorted handmade Chinese, Japanese, Korean, Indian, Mexican, and French papers

blotters

brayers

cheesecloth

Chinese glue brushes (such as AJKE)

disposable gloves

domestic mill papers (such as Carriage House, Rugg Road)

etching ink in a variety of colors

etching press

gesso

mat board for base

metal wire

printmaking paper (such as Rives BFK)

PVA glue (such as Elmer's Glue-All)

sharp tools for scratching into the inked plate

string

1 Berringer lays out pieces of paper and string on the collagraphic base, a large piece of mat board.

2 The artist attaches the selected materials to the collagraphic plate with gesso.

3 Here Berringer seals the plate, first using gesso and then an application of acrylic gel medium for an even finish. This treatment prevents the fabric and paper elements from absorbing ink like a sponge, which would then result in a messy blur when run through the press. The acrylic coating will allow the ink to pool in the crevices, lines, and indentations that define each element's surface, thus reproducing each item's unique texture in the collagraph print.

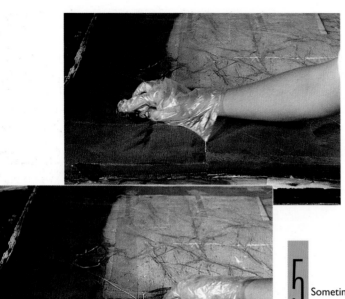

4 After mixing the colors, the artist begins to ink the plate. She uses a number of tools to apply the ink, including brayers, brushes, squeegees, tarlatan (a stiff cloth), and even her hands; here, she uses a piece of cheesecloth. Berringer wipes some areas after applying ink, to lighten the color or to smooth the application. Sometimes she works back and forth between applying and wiping, building up colors in some areas and lightening or blending them in others.

5 Sometimes the artist scratches designs into the wet ink.

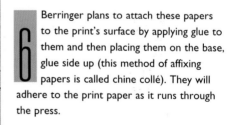

6 Berringer plans to attach these papers to the print's surface by applying glue to them and then placing them on the base, glue side up (this method of affixing papers is called chine collé). They will adhere to the print paper as it runs through the press.

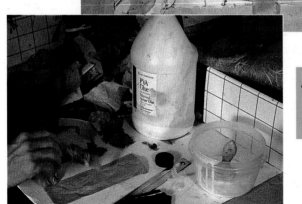

7 Berringer applies a thin coating of PVA glue to a delicate paper, which will form part of the print's surface.

8 Here the artist rolls the dampened sheet of printmaking paper over the plate, which combines inked collage elements and pieces that will be glued onto the print's surface. After the felt-printing blankets are placed over the paper, the printing process can begin. The scale of Berringer's prints requires a press with a 48-by-84-inch bed.

9 The artist checks the printed image at the press, to ensure that the applied papers have bonded well. She will re-glue any loose pieces. It is preferable to do re-gluing at this stage, rather than to apply too much glue to the papers before printing—since the glue may seep through the paper onto the felt blankets.

10 To dry the piece, Berringer places it between tissue papers and blotters; then it is pressed between boards for several days until it is dry.

11 After the drying is complete, Berringer enhances the print with pastels, graphite, and oil crayon.

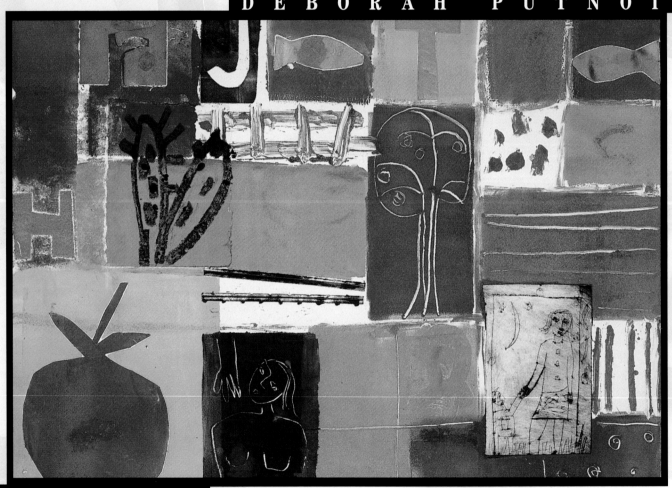

DEBORAH PUTNOI

COLLECTIVE
Memory

Deborah Putnoi's world reflects her interest

in the themes of community and the way that collective memory is transmitted from generation to generation. She often employs imagery from everyday life, such as the human figure, domestic animals, playing children, and food. A sense of continuing dialogue is present in her work because of her frequent use of text and letters, her incorporation of pieces of her old work and old drypoint plates, and the way that one piece often suggests the themes of following works.

Putnoi rarely plans her pieces in advance. She works spontaneously, combining cutout shapes, applied papers, figures scratched into areas of paint, and ink drawings. She revises her work as she goes along, rearranging elements, drawing or painting over images, and trimming cut pieces to refine their shapes. She skips some of the traditional, methodical techniques of printmaking, such as sealing the plate and wiping areas of ink into place; instead, she prefers to work quickly and instinctively, allowing the random effects of the printing process to lend immediacy to her work. Putnoi's output is prolific, and she keeps a visual journal to provide inspiration and to generate new ideas.

Green apple + T
Monoprint
11" x 15" (28 cm x 38 cm)

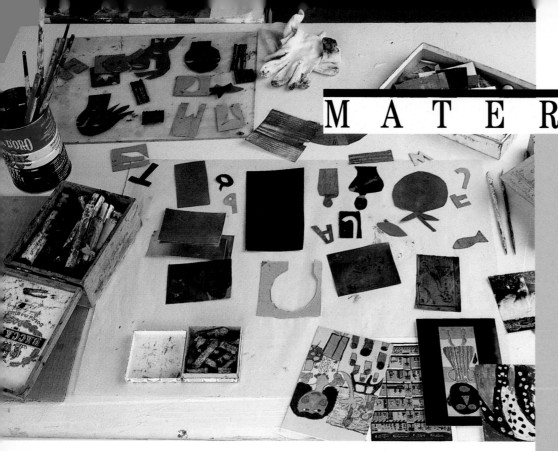

MATERIALS

P utnoi uses a variety of materials in making her prints—her own used drypoint plates, remnants of her prints, cardboard cutouts, cloth, twist ties, flattened bottle caps—any odds and ends that are interesting in shape and texture.

assorted fabrics and papers

bamboo ink brush

blotter paper

brayers in different sizes

disposable gloves

etched aluminum drypoint plate

etching press

etching tools

X-Acto knife

Japanese calligraphy ink

mineral oil

oil paint in a variety of colors

paintbrushes

paper (such as Stonehenge)

palette knife

Plexiglas base

Plexiglas palette

PVA glue (such as Sobo Premium Craft & Fabric Glue)

scissors

thin cardboard with a finished side (such as Bristol board)

After she chooses her collage materials, Putnoi begins to lay out her palette. She mixes oil paints with a palette knife on a Plexiglas palette, which she can wipe off easily and reuse.

Using a brayer, the artist applies paint to the sheet of Plexiglas that will serve as the base for the plate. She continues to mix and alter her paint palette throughout the process of preparing the plate. The disposable cloth gloves help keep the paper clean.

At this stage, Putnoi draws into an inked area of the base with the end of a paintbrush. She also applies cutout collage elements, inking them before placing them on the base. An old drypoint plate has been freshly inked to transfer its image to the paper as well.

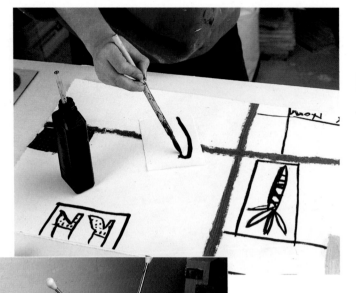

4 Putnoi often glues collage elements directly onto the clean printing paper prior to running it through the press. Here she is creating such a piece, using Japanese calligraphy ink and a bamboo brush. When this piece has dried, it will be glued onto the printing paper.

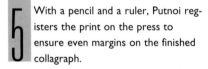

5 With a pencil and a ruler, Putnoi registers the print on the press to ensure even margins on the finished collagraph.

6 In the final step before printing, the artist has selected a piece of an old print to apply facedown on the plate. Glue on the side facing up will affix the piece to the printing paper as it passes through the press.

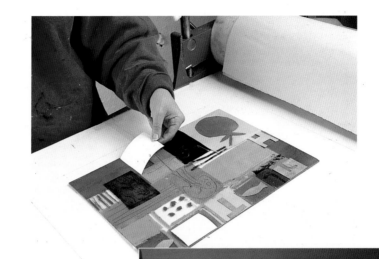

7 Putnoi runs the print through the press. In order for the image to transfer clearly, she has to run it through more than once.

Wet/Dry Technique

You might experiment with using both wet and dry paper for printing your collagraph, as Putnoi does. Dry paper can work well, provided that the collage elements are quite flat; a wet paper will absorb more ink and receive a clearer impression of textures and relief.

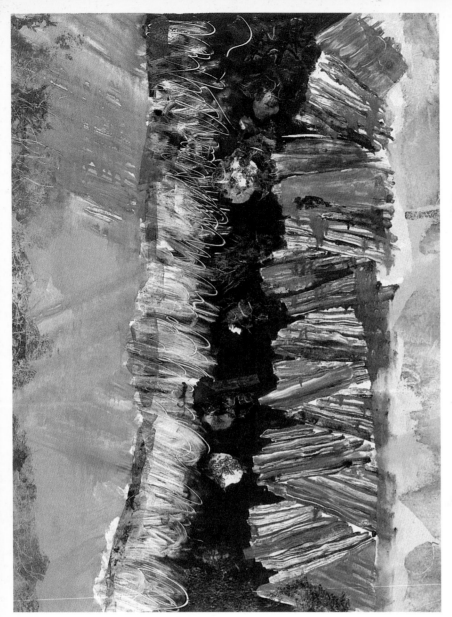

▲ **Diane Miller**
Noon Waterfall
Monotype collage
25" x 19" (64 cm x 48 cm)

GALLERY

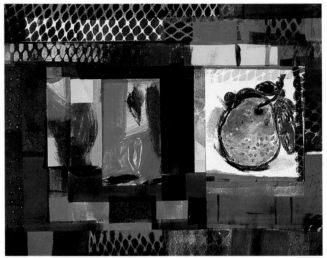

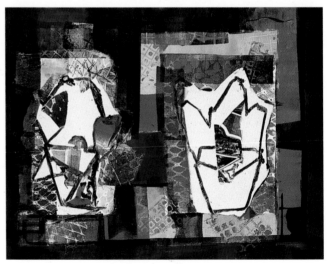

▲ **Emily Myerow**
Chinese Take-Out #1
Monotype collage
14" x 18" (36 cm x 46 cm)

▼ Diane Miller
Waterfall IX
Monotype collage
25" x 19" (64 cm x 48 cm)

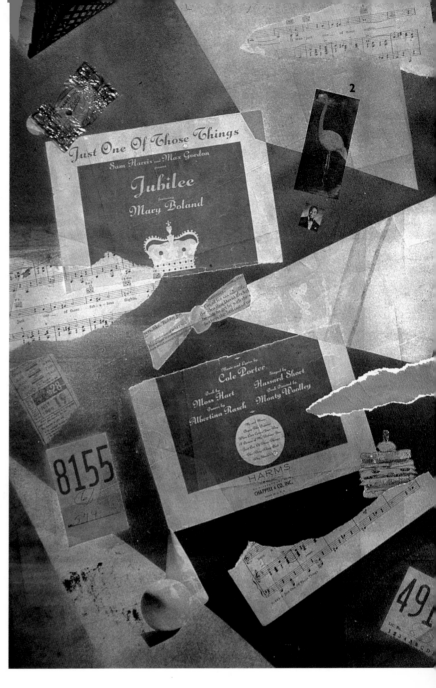

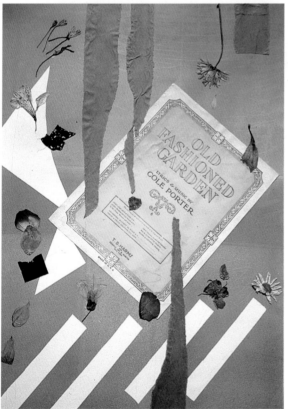

◄ **Betty Guernsey**
Old Fashioned Garden
Mixed media monoprint
30" x 20" (76 cm x 51 cm)

© *Betty Guernsey, New York City*

▲ **Betty Guernsey**
Jubilee
Mixed media monoprint
30" x 20" (76 cm x 51 cm)

© *Betty Guernsey, New York City*

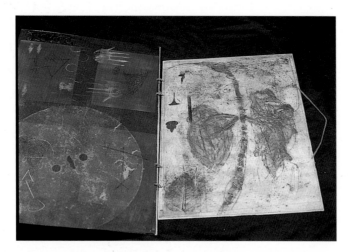

◀ **Meryl Brater**
Pugillaris
Collagraph
28.5" x 90" (72 cm x 229 cm)
(detail, left)

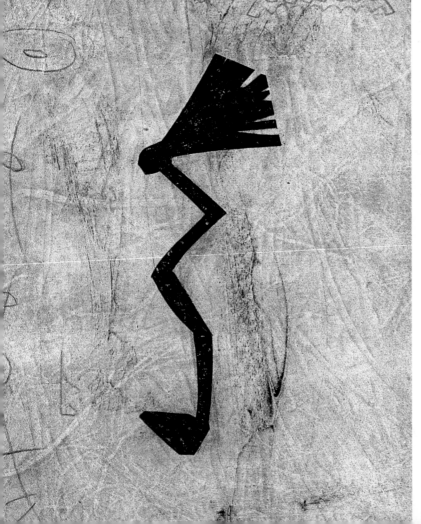

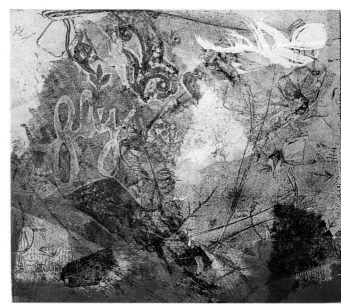

▲ **Debra L. Arter**
Thoughts on Flight II
Collagraphy with unryu paper, stencil
resist, and *chine collé*
9.5" x 9.5" (24 cm x 24 cm)

◀ **Meryl Brater**
The Form of Language Book II
Collagraphy with drawing
8.5" x 6.5" (22 cm x 17 cm)

Robert Kelly ▶
Suttra Series
Collagraphy with mixed media
26" x 36" (66 cm x 91 cm)

▼ **Debra L. Arter**
Violet Tidal View II
Collagraphy with *chine collé*
8" x 6" (20 cm x 15 cm)

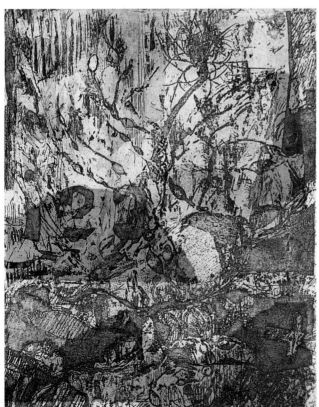

▲ **Robert Kelly**
Kairos III
Collagraphy with mixed media
50" x 45" (127 cm x 114 cm)

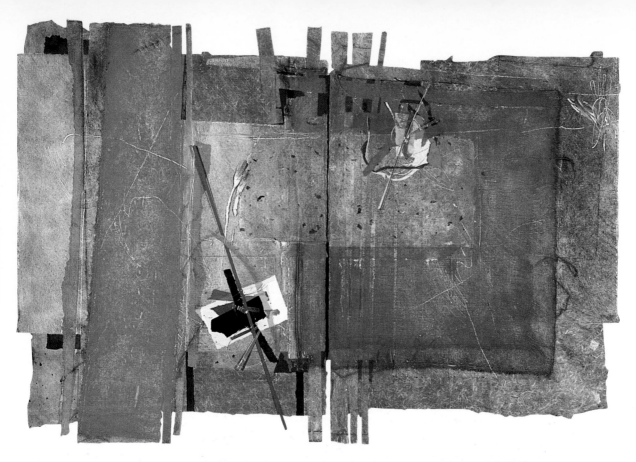

◀ **Jennifer Berringer**
Roma
Collagraph
28" x 40" (71 cm x 102 cm)

Jennifer Berringer ▶
Polydore
Collagraph
60" x 80" (152 cm x 203 cm)

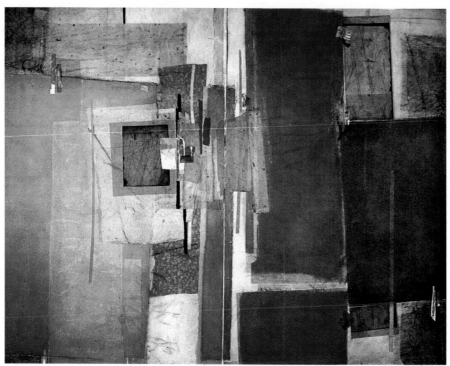

Deborah Putnoi ▶
and when we
Monoprint
12" x 30" (30 cm x 76 cm)

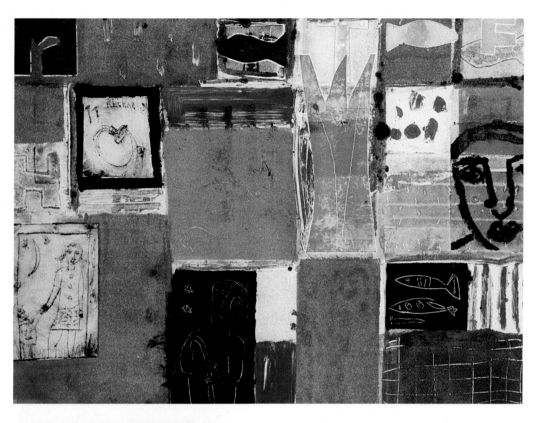

◀ **Deborah Putnoi**
For Both
Monoprint
18" x 24" (46 cm x 61 cm)

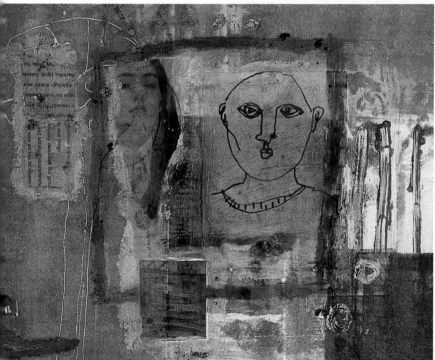

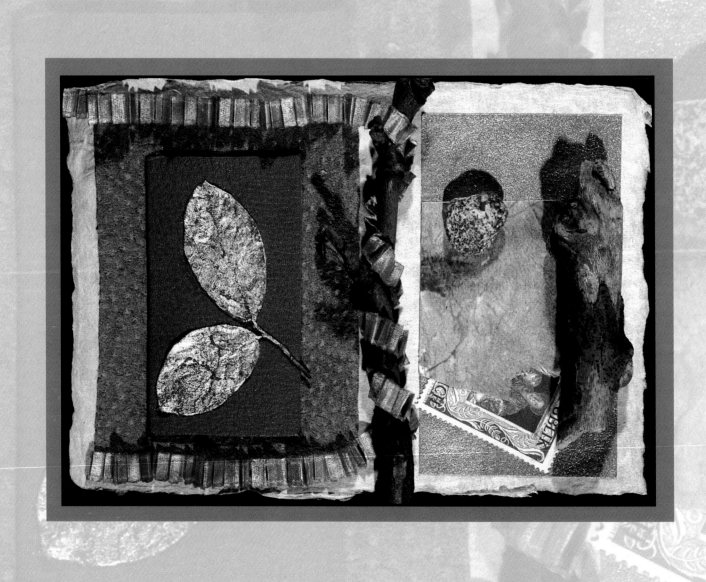

Found Object
COLLAGE

Found object collage (sometimes called assemblage) draws two- and three-dimensional objects from everyday life, both organic and man-made, into the realm of art. The associations we attach to particular items and the way they are juxtaposed may evoke a sense of harmony or dissonance, serenity or turmoil, unity or disarray. This form of collage is now in its heyday because of the contemporary interest in recycling, the nostalgia for mass-produced icons of pop culture (such as Mickey Mouse watches, buttons from presidential campaigns of the past, outdated kitchen appliances, and mood rings), and the twentieth century's broadened definition of the materials and themes that can constitute art. Yet, in addition to its role as a fine art medium, found object collage may be used to decorate many domestic items, such as frames and boxes.

Carole P. Kunstadt
Memories
Collage with mixed media
4" x 6" (10 cm x 15 cm)
Mark Karlsberg

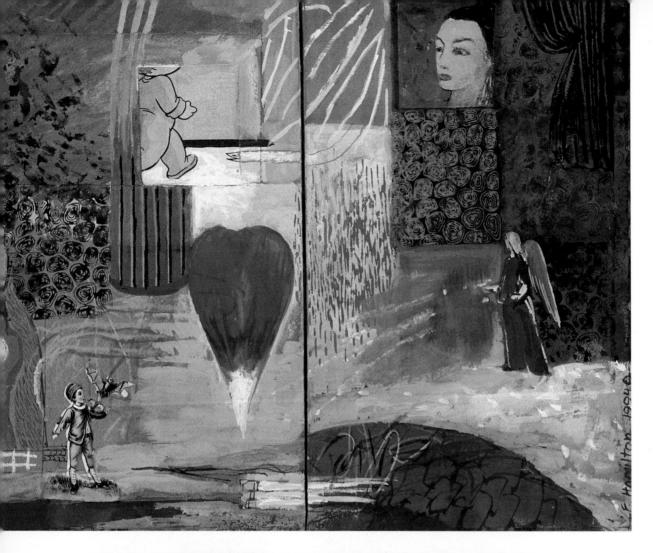

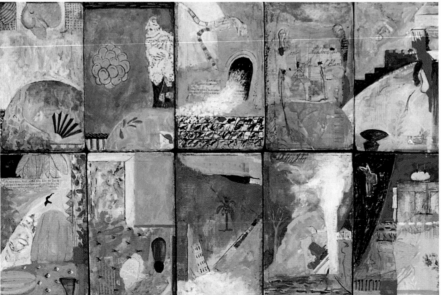

▲ **Frances Hamilton**
Angel
Collage with gouache
9.5" x 11.5" (24 cm x 29 cm)

◄ **Frances Hamilton**
Going Home
Collage with gouache
16.5" x 25" (42 cm x 64 cm)

Creating this type of collage involves securing found objects to a base. Glue, nails, hooks, or other means may be used. The objects themselves may be enhanced with paint or distressed to lend the effect of aging. The rules for creating found objects collage are few, and they involve practical considerations, such as choosing fasteners that will firmly support the objects.

This chapter's featured artists use found objects in different ways. Douglas Bell employs them as collage elements in his abstract paintings. Ben Freeman makes found objects the focus of his work, beginning each collage by creating a sketch and choosing pieces that will mesh together to suggest a narrative. Both artists, like Joseph Cornell, look beyond an item's original purpose, reinterpreting it and endowing it with new meaning.

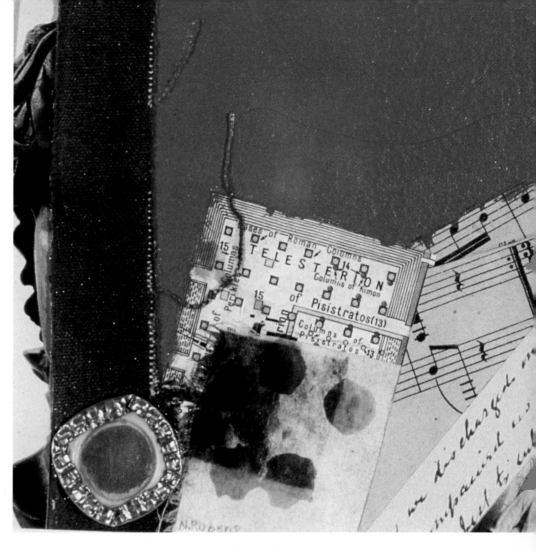

Nancy Rubens
One's Own Time
16" x 12" (41 cm x 30 cm)

Found Object
MATERIALS

For most collages employing three-dimensional

items, a sturdy foundation such as plywood, mat board, multidensity fiberboard, Masonite, or cardboard should be selected as a base. Each option has benefits and drawbacks. Plywood is strong, inexpensive, and easy to find, but it can warp. Multidensity fiberboard, which is made from compressed wood pulp, does not warp and is also inexpensive, but it is heavy and thus can be awkward to work with. Masonite is less porous than wood and will not warp, but it costs more and can be hard to find. Mat board is lightweight and sturdy, comes in many colors, and is acid-free and therefore relatively permanent; however, it is too thin to support all but the lightest found objects. Cardboard, the least expensive and most readily available base, is less sturdy and less permanent than the other possible choices.

You could also use a found object as a base, provided that it is strong and stable enough to support the other objects. An old kitchen cabinet door, a shallow crate, a large cutting board, even an old Beatles' album jacket—or the vinyl record itself—could serve as the foundation for the collage. When you attach the other objects, choose a fixative that will not harm the found object base.

Fasteners must be strong enough to permanently support the weight of a given object. For heavy items, staple guns can be handy to use, but the staples tend to stand out, and an object might be marred by them. Screws and nails can attach an object firmly, and the heads can be covered with wood putty or another material, making them invisible in the finished collage.

Ellen Wineberg
Thanatos
Monotype collage with woodcut on paper
27" x 26" (69 cm x 66 cm)

Or you might prefer to leave such hardware visible, making it an integral part of the collage; consider using weathered nails, colored tacks, or decorative brackets. Eccentric choices such as clamps, metal chain, roping, or hooks might suit certain collages.

To attach papers, fabrics, and other lightweight items, use a glue that will bond the material to the base successfully. Acrylic gel is a good adhesive for papers and fabrics; once it dries, it will be transparent and colorless. Gesso (white acrylic polymer) also works well on paper, fabric, mat board, and Masonite. You can also use it to create texture on the surface of the base. Rubber cement affixes paper smoothly, but note that the paper can also be peeled off again—the bond is not permanent. Water-soluble PVA glues such as Elmer's Glue-All and Sobo Premium Craft & Fabric Glue are convenient for gluing fabric and paper.

Items made of wood, glass, plastic, and metal require other fixatives. You might choose Elmer's Wood Glue to attach wooden objects to the base. Silicone adhesive works well on glass and metal. Epoxy resins will secure plastics and metals; they can be purchased in hardware stores in a variety of forms. They produce a strong, permanent bond but are toxic—observe the directions and warnings on the label. Superglues also provide a permanent bond for many materials, but they too are toxic and must be used with care.

After all the objects are affixed, allow the piece to dry thoroughly. Check that each item is bonded securely before displaying your finished work.

Peter Madden
Sinister Nature
Collage transfers on cotton, copper, brass, wood
30.5" x 39" (77 cm x 99 cm)

Found Object
TECHNIQUES

To begin a found object collage, gather a variety

of objects such as cigar boxes, seashells, broken crockery, old photos, buttons, small baskets, driftwood, scraps of metal, sea glass, game pieces, an old calendar, playing cards, a baseball cap, dice—whatever strikes your fancy. Don't forget to consider bits and pieces of your old artwork that might suit your theme. Found objects can be composed on a flat surface or arranged in boxes or other containers. You might group souvenirs from a favorite holiday or gather mementos from a significant year in your life; or you may mix seemingly disparate objects that evoke a theme or have a subtle relationship.

Once you have collected your objects, decide on the base for your collage. Plywood will successfully support heavy objects; mat board or canvas will serve well for very light objects. You may wish to treat the base with paint (anything from a wash to a detailed painting) or to texture it with gesso before applying the found objects. Rearrange the pieces on the base until you are satisfied with the composition.

You can also enhance the individual objects of the collage in a number of ways, both to create interesting effects and to stabilize fragile elements. Paper and fabric items can be torn, twisted, shredded, or folded; heavier objects can be distressed by scratching, sanding, or nicking; a variety of elements can be stenciled or written on. You can apply a backing to fragile fabrics to help them hold their shape. Dip dry flowers or leaves in acrylic medium to preserve color and shape.

After the individual elements and the layout of the collage are in order, the practical considerations of assembling the work take over.

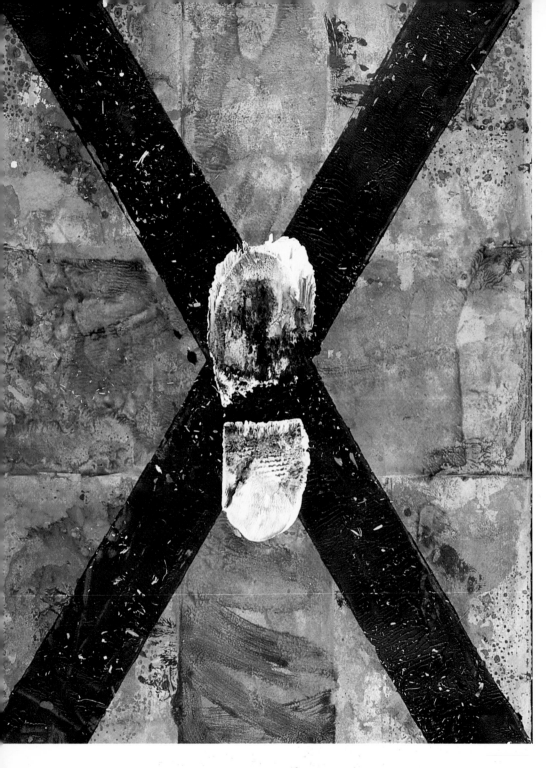

How will you attach the objects to the base? Decide which pieces should be fastened with glue and which will need stronger support. Generally, papers, fabrics, and lightweight objects can be affixed with glue; choose a glue that suits each material. You may need to experiment with various glues and the amount to apply to ensure a firm bond.

Heavier objects will need to be attached with hardware. Nails, screws, or hooks can work well. Tailor the size of the hardware to the thickness of the base—a nail that is too large will split a thin board. Experiment, or ask a knowledgeable assistant at the hardware store to help you select the best hardware for your purposes.

Douglas Bell
Untitled
Collage with acrylic and mixed
media on paper
30" x 22" (76 cm x 56 cm)

Attach the collage elements in a logical sequence. For instance, if a large horseshoe is to be nailed in place next to a fragile bunch of dried flowers, apply the horseshoe first to prevent damaging the flowers with the pounding of the hammer. Consider applying the largest objects first, followed by the smaller details. Let glued areas dry thoroughly, and check that each object is fixed securely.

Once all the pieces are attached to the base, a few finishing touches may be in order. You might add painted details, cover nailheads with putty, apply subtle finishes such as glitter or spattered paint to parts of the collage, or sand rough areas to put a final polish on your work.

William Harrington
Art as Therapy
Collage with mixed media
10" x 12" (25 cm x 30 cm)

Ellen Wineberg
Cardinal
Collage with pastel on paper
16" x 20" (41 cm x 51 cm)
Photo by David Caras

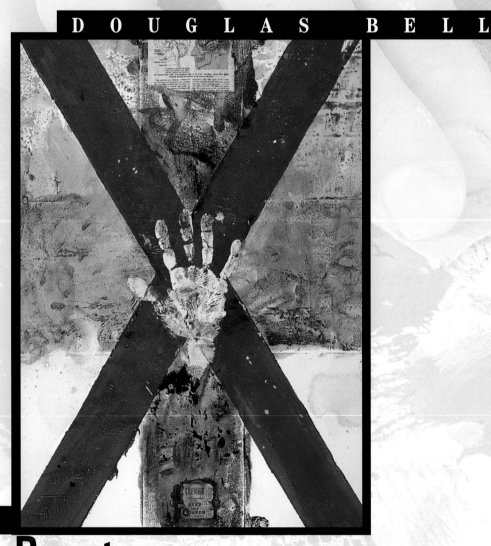

DOUGLAS BELL

OBJECTS
With a Past

When he works with found objects, Douglas

tries to recapture the thrill of making things that he felt as a child. His two- and three-dimensional paintings incorporate found objects imbued with an archaeological feeling, as if they have been rediscovered and given a new incarnation in his artwork. He often uses worn objects, or distresses the surfaces of newer ones, so that they evoke the past. Though the viewer may recognize something familiar in the items he uses, his presentation of an object-removed from its typical context, surrounded with other images, and perhaps layered with paint or other materials-gives it a sense of mystery.

Bell's use of materials stems from an artistic frugality; he makes do with the materials at hand and likes to fix and save things for future use. He employs trimmings from unfinished paintings and drawings, building personal history and a sense of continuity into his works. His unusual ways of using paint—daubing it onto boards or papers, and then applying it to his work—add interesting textures.

Certain themes recur in Bell's work. He is particularly interested in the way numbers and letters can represent superstitions, symbolic meanings, the uncertainties of chance and gambling, mystery, and a means of control. Bell also explores the human tendency to apply systems to random events in order to organize and understand life.

Red X with Tickets
Paper and found object collage with oil paint
30" x 22" (76 cm x 56 cm)

MATERIALS

acrylic paints

assorted collage materials, including tickets

board for applying paint

brayer

extra-heavy acrylic gel

paintbrushes in various sizes

palette knife

paper for base (such as Rives BFK)

sandpaper

scraps of paper

squeegees

water

Bell collects boxes of surplus objects (especially similar items in multiples), tickets, wooden wheels, glass bottles, numbered map pins, scraps from various manufacturing processes, and other found objects. Here, he assembles some of the objects, together with pieces of his artwork, to begin composing his collage.

1 Bell applies an acrylic-and-water wash to the base of his collage. This wash is the first of many that he will use to build color on the surface.

2 Bell decides on the placement of the collage elements. He will affix them with gel medium and a small paintbrush on the paper base.

Wash and Dry Tip
Between steps, let washes and acrylic gel dry completely, to ensure clear colors and the successful completion of the next step.

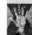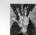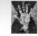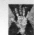

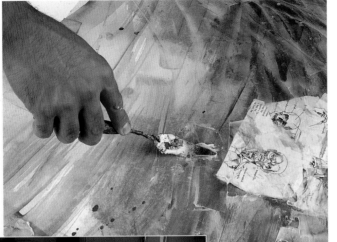

3 To create surface texture, Bell uses a palette knife to add a layer of gel medium over the entire base.

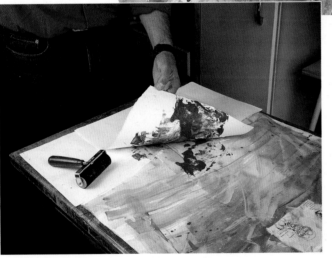

4 At this point, Bell covers certain areas of the collage with scrap paper so that they will remain white. He then daubs paint onto another piece of paper, which he places facedown on a section of the base. After applying pressure with a brayer, he slowly peels back the paper to reveal a stippled pattern of paint.

Save the Scraps

Save the pieces of paper used to apply paint in this way. They often have interesting patterns that might be useful in your next project.

5 Bell uses a number of unorthodox techniques to add color to his collages. For this piece, he applies red paint to a two-by-four, which he then places facedown on the collage (the collage has been placed on a drop cloth). He walks on the board to apply pressure.

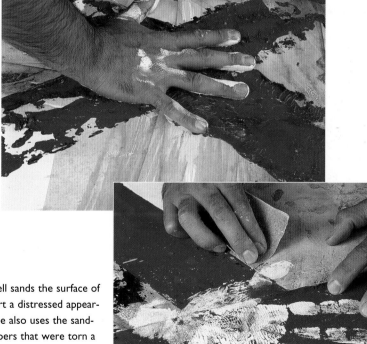

6 The artist adds a handprint to the center of the painted X by coating his palm with white acrylic paint.

7 For the final step, Bell sands the surface of the painting to impart a distressed appearance to the work. He also uses the sandpaper to smooth papers that were torn a bit during the application of paint.

BEN FREEMAN

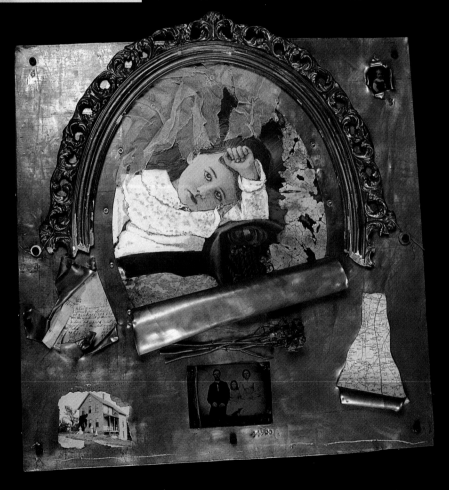

SCRAPBOOK
Images

Ben Freeman's work expresses his nostalgia

for the past while creating a reference point for the present. In his collages, studded with old photographs and architectural elements, he employs images that seem familiar—perhaps similar to those in the viewer's old photograph albums at home. But the mysterious people and places in these photographs are also strangers whom we want to know, to fit into a narrative suggested by the found objects surrounding them. Thus Freeman takes the viewer into the past while bringing the past into the present.

Freeman has scouted antique stores and flea markets to gather images of intriguing people and evocative places. He begins a collage by choosing a subject from his collection of vintage photographs, often enlarging the image and embellishing it with painted details. He also incorporates into his collages old maps, postcards, journals, and letters—the souvenirs to which people attach memories. These details, though they may provide hints to the viewer concerning the subject's mood, identity, and experience, mainly express the mystery of human life and the ephemeral nature of human experience.

Unfinished Works: Diane
Found objects on wood
36" x 36" (64 cm x 64 cm)

MATERIALS

Freeman decides to focus his found object collage on a tiny photograph of a little girl wearing a melancholy expression. He also makes selections from his stash of old maps, photographs of places, lace and other fabric, parts of vintage frames, architectural elements, writings, and handmade and found papers.

acrylic gel

acrylic paints

antique documents

assorted found objects

canvas textured with plaster

colored pencils and graphite

hardware to attach collage elements (such as nails, screws, and wire)

industrial contact cement

lace and other fabric swatches

lead sheeting

oil stick (such as Winsor Newton)

oil varnishes (such as Winsor Newton Matte)

old photographs

plywood board for base

stretcher bars

1 Freeman has had the photograph of the girl enlarged. Using contact cement, he has glued the enlargement to the plywood base. He applied the cement with a broad brush and then affixed the image to the plywood beginning at one edge, rolling out the photograph smoothly to leave no bubbles under the surface. Now he considers other elements that might complement the photograph.

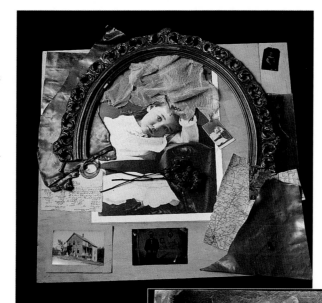

2 Next, Freeman works on enhancing the image with oil paints and graphite.

Using a Glue Brush

Using a broad brush to apply glue helps in making a quick, thorough application; none of the glue will begin to dry before the object is applied to the base, and the even application will help ensure a smooth surface.

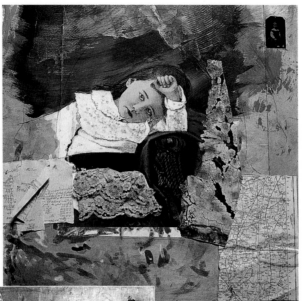

3 The artist narrows his choices of collage elements by juxtaposing them with the completed image of the girl. He considers adding fabric details, such as lace to enhance the dress. Freeman then attaches the paper pieces with gel medium and the three-dimensional pieces with contact cement.

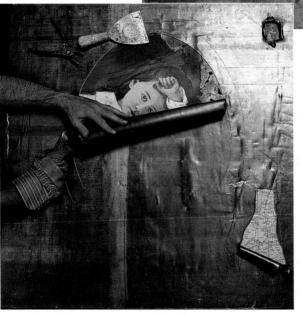

4 Now Freeman covers the entire piece with a large square of lead sheeting. The lead is smoothed with a roller to flatten it completely against the plywood surface and then is secured with stretcher bars. Next, the artist begins the process of cutting away certain areas with a mat knife to reveal the collage elements beneath it. He can feel the edges of the photographs beneath the soft lead and thus knows where to cut. (Because of lead's toxicity, dispose of any scraps where children can't reach them.)

5 Freeman creates a neat, rolled-back edge to set off the photograph of the little girl and the swatch of the map. He uses a crinkled, irregular edge to reveal a part of the handwritten letter and the tiny photograph in the corner.

6 After the cutting of the lead sheet is finished, Freeman considers the placement of collage elements that will be affixed to the surface of the lead sheet. At this stage Freeman begins to apply the other surface objects—a tintype, a photograph, a bunch of dried roses sealed in acrylic medium, a fragment of sheer fabric, and part of an old frame.

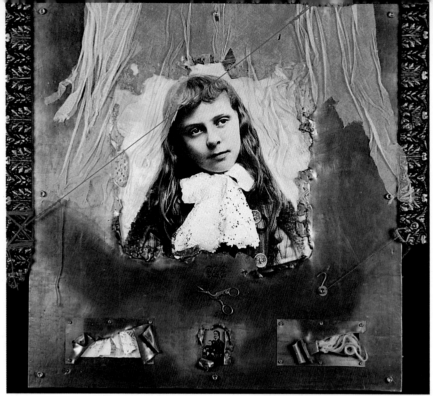

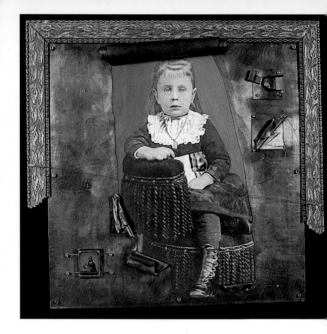

▲ **Ben Freeman**
Unfinished Works: Julie
Photograph, found objects on wood
36" x 36" (91 cm x 91 cm)

▲ **Ben Freeman**
Unfinished Works: Claire
Photograph, found objects on wood
36" x 36" (91 cm x 91 cm)

Douglas Bell ▶
Mermaid
Collage with oil, acrylic, and mixed
media on paper
9" x 7" (23 cm x 18 cm)

GALLERY

▲ **Nancy Rubens**
Handle with Care
18" x 14" (46 cm x 36 cm)

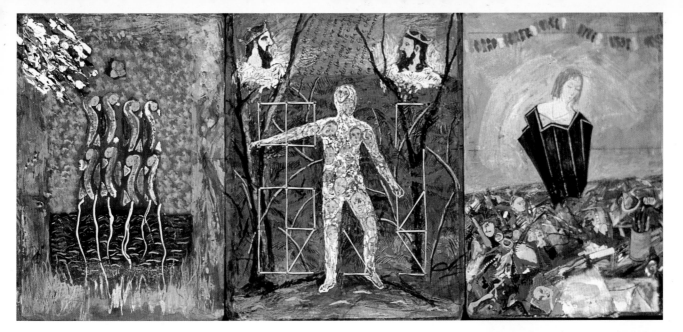

▲ **Francis Hamilton**
Dante
Collage with gouache
11" x 33" (28 cm x 84 cm)

▲ **Francis Hamilton**
Everyday Fun
Collage with gouache, cast paper, wood
17.5" x 24" (44 cm x 61 cm)

◄ **William Harrington**
A Repro
Collage with mixed media
10" x 12" (25 cm x 30 cm)

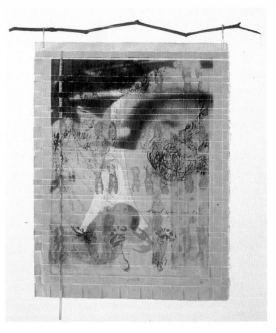

▲ **Lori A. Warner**
Untitled
Solvent transfer on woven oriental paper
8" x 6" (20 cm x 15 cm)

▲ **Ellen Wineberg**
Number 6
Monotype collage with woodcut on wood
28" x 29" (71 cm x 74 cm)

Lori A. Warner ▶
Epigenesis
Solvent transfer with silkscreen intaglio
on woven painted paper
14" x 11" (36 cm x 28 cm)

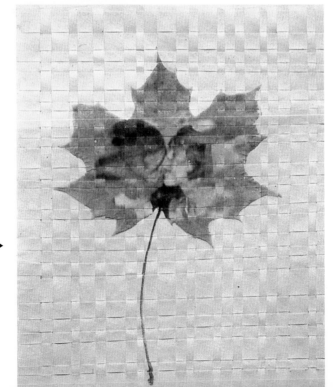

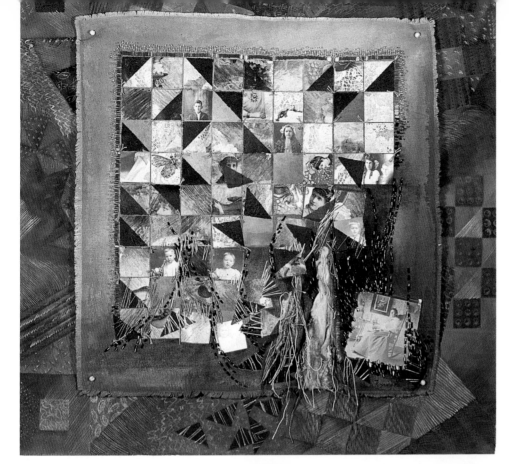

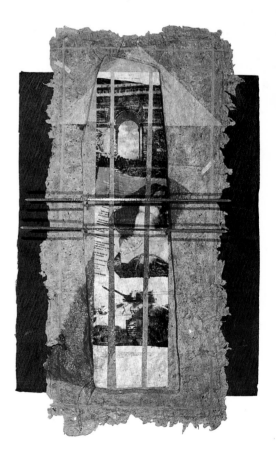

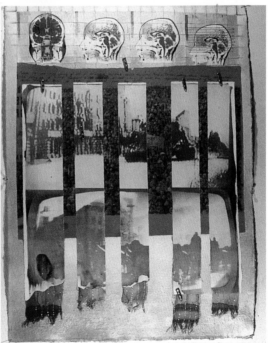

◄ Janice Fassinger
Loss of Comfort
Collage with painted canvas, photographs,
fiber, and beads
25" x 25" (64 cm x 64 cm)

▼ Susan Hass
Ancient Runes
Collage with cyanotype, brownprint,
plastic, wire, string, kozo paper, and
handmade paper
44" x 29" (112 cm x 74 cm)

Susan Hass ►
Collective Memory
Collage with alternative photo process
30" x 20" (76 x 51 cm)

133

▲ **Joyce Yesucevitz**
Remembrance
Collage with acrylic on linen
9" x 21" (23 cm x 53 cm)

▲ **Joyce Yesucevitz**
Cows
Collage with acrylic and burlap on canvas
60" x 48" (152 cm x 122 cm)

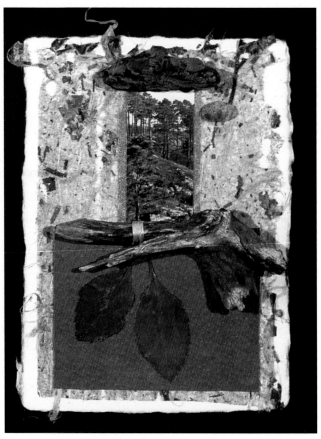

▲ **Carole P. Kunstadt**
Funghi
Collage with mixed media
6" x 12" (15 cm x 30 cm)
Photo by Robert Kunstadt

▲ **Carole P. Kunstadt**
Above Treeline
Collage with mixed media
8" x 6" (15 cm x 20 cm)
Photo by Robert Kunstadt

▲ **Dawn Southworth**
Untitled
Collage with mixed media
18" x 15" (46 cm x 38 cm)

◀ **Dawn Southworth**
Untitled
Collage with mixed media
18" x 15" (46 cm x 38 cm)

Peter Madden ▶
Biography
Collage transfers on cardboard
18" x 24" (46 cm x 61 cm)

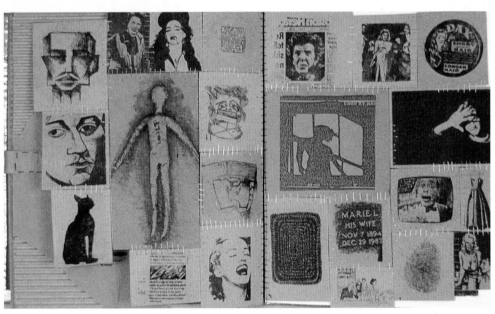

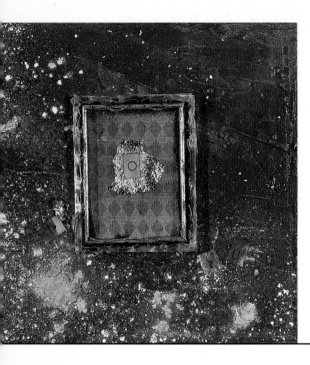

Douglas Bell
97 Walk Hill Street
Jamaica Plain, MA 02130
617-522-7068
or:
c/o Clark Gallery
P. O. Box 339
Lincoln, MA 01773
617-259-8303
617-259-8314 fax

◄ **Douglas Bell**
IOU
Collage with acrylic and mixed media
on canvas
12" x 12" (30 cm x 30 cm)

Doug Bell has spent most of his adult life as an artist trying to recapture "the thrill of making things" he felt growing up in Smithfield, Rhode Island. As a child, he built model kits and customized them with scraps in his basement workshop. As a young man, Bell considered channeling his creativity into a career as an architect or engineer. Although he had a number of artistic interests, including choral singing and painting "sets" for the theater, he realized in college that his true calling was to become an artist.

Bell majored in sculpture at Rhode Island College, and, upon graduating, became a member of the cooperative Bromfield Gallery in Boston, Massachusetts. In 1986, he began exhibiting his work at the Clark Gallery, Lincoln, Massachusetts, and has since been featured in many one-man and group shows.

Jennifer Berringer
9300 Pine View Lane
Clinton, MD 20735
or:
c/o Clark Gallery
P. O. Box 339
145 Lincoln Road
Lincoln, MA 01773

▼ **Jennifer Berringer**
Kinship
48" x 64" (122 cm x 163 cm)

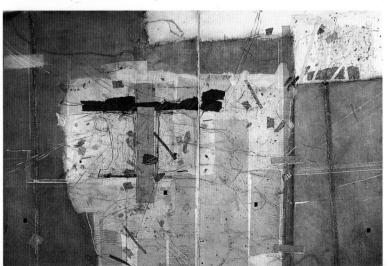

Jennifer Berringer received her degree in art and religion from Montclair State University in 1972 and has been working as an artist since. Berringer lived in Boston, Massachusetts from 1978 through the early 1980s, a prolific period she describes by saying, "At that stage in my life, I was fortunate to have a lot of time to make artwork." A year in Denmark convinced her to apply her talents exclusively to her art and to aggressively pursue an art career. As she states, "As you learn techniques, you make images and spend time building a visual vocabulary. I was looking for a medium to express what I wanted to say. After some early experiments with wax painting, she settled on the medium of collography in 1978.

Sandra Donabed
130 Washington Street
Wellesley, MA 02181
617-237-6390

Sandra Donabed grew up in Buffalo, New York, the daughter of a home economics teacher. She made doll clothes as a child and her own clothes as a young woman. After completing a degree in design at Syracuse University, she moved to Boston, received an education degree from the Massachusetts College of Art, and began teaching high school art in Wellesley, Massachusetts. Donabed's interest in quilting began in the early 1980s, when she joined a class that focused on traditional handwork.

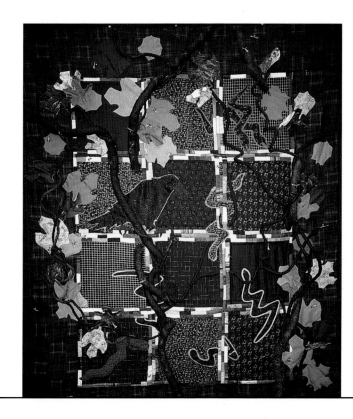

◀ **Sandra Donabed**
Fireflies
45" x 54" (114 cm x 137 cm)

Ben Freeman
300 Summer Street
Boston, MA 02116
617-482-1721
or:
c/o Barbara Krakow Gallery
10 Newbury Street
Boston, MA 02116

Ben Freeman received his degree in architecture in 1969, from the University of North Carolina. He moved to Cambridge, Massachusetts, where he received a Harvard fellowship to study in the Paris office of Le Corbusier. He later did graphic design for French television, where he met and became friends with other artists. These influences lead Freeman to begin painting. He returned to the United States in 1972, with the intention of practicing architecture for a short time before returning to Paris. Instead, he stopped practicing architecture—in favor of art—that same year.

His work has been exhibited in Paris salon showings, and in galleries in Houston, New York, Chicago, and Boston. His work also has been shown in group exhibitions at the De Cordova Museum and Currier Gallery of Art.

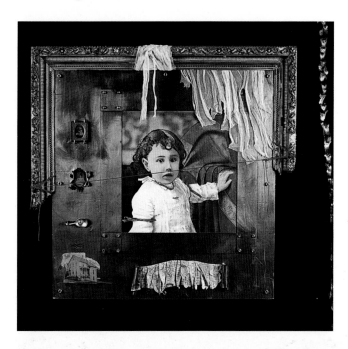

◀ **Ben Freeman**
Unfinished Works: Lanette
36" x 36" (91 cm x 91 cm)

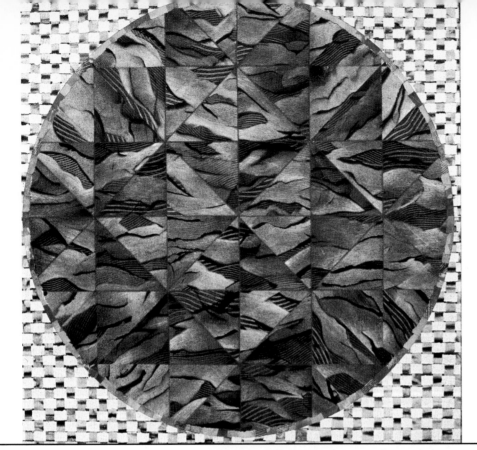

Karen McCarthy
141 Warren Street
Arlington, MA 02174

A Boston-area native, Karen McCarthy attended the Massachusetts College of Art, Boston, and the Haystack Mountain School of Crafts in Deer Isle, Maine. McCarthy exhibits her work in galleries and non-profit exhibition spaces throughout the United States; her art is well represented in both private and public collections.

◀ **Karen McCarthy**
Solitaire: For Lenore Tawney
Paper with pigmented starch paste, thread, and colored pencil
26" x 26" (66 cm x 66 cm)

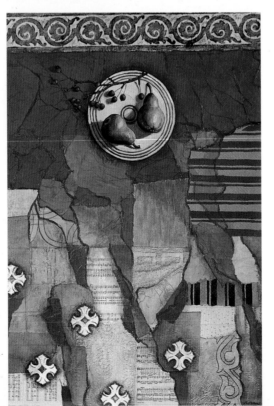

Rachel Paxton
4 Harris Avenue
Jamaica Plain, MA 02130
617-427-1065
or:
c/o Clark Gallery
P. O. Box 339
145 Lincoln Road
Lincoln, MA 01773
617-259-8303

Born and raised in Greenwich, Connecticut, Rachel Paxton studied textile design at the Rhode Island School of Design, Providence, Rhode Island. She later attended the School of the Museum of Fine Arts, Boston. Although she uses only paper in her collages, her fabric design background is evident in her work. She has exhibited her work widely in galleries and museums through the United States.

Rachel Paxton ▶
Split Middle Ground, 2:00
Paper with mixed media
43" x 29" (109 cm x 74 cm)

Deborah Putnoi
171 Fayerweather Street
Cambridge, MA 02138-1242
617-876-2006
or:
c/o Clark Gallery
P. O. Box 339
145 Lincoln Road
Lincoln, MA 01773

Deborah Putnoi attended Tufts University, Medford, Massachusetts, and the School of the Museum of Fine Arts, Boston, where she earned a BA in Political Science and BFA in Studio Art. She then attended the SMFA where she obtained her fifth year diploma in painting and printmaking. In 1990, Putnoi earned a Master of Education degree from the Harvard Graduate School of Education. She worked for a number of years at Harvard Project Zero where she did research on community art centers in economically disadvantaged communities and on museum education.

▼ **Deborah Putnoi**
green t and black j
Monoprint
11" x 15" (28 cm x 38 cm)

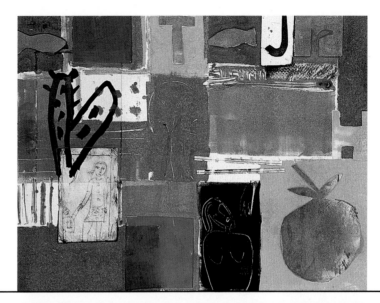

Clara Wainwright
57 Upland Road
Brookline, MA 02146
617-628-0060

Clara Wainwright is an artist with a strong commitment to community involvement, and has created community quilt projects with both adults and teenagers. She began working in fabric collage with little formal training. Born and raised in Boston, Wainwright studied literature at the University of North Carolina, and did not become interested in quilting until she was given a quilt when her son was born. She has created pillows, books, and community and youth quilts that have been exhibited in museums and university galleries throughout the Northeast.

Clara Wainwright ▶
Entrance to a Folly Cove Garden
Fabric collage
31" x 31" (79 cm x 79 cm)

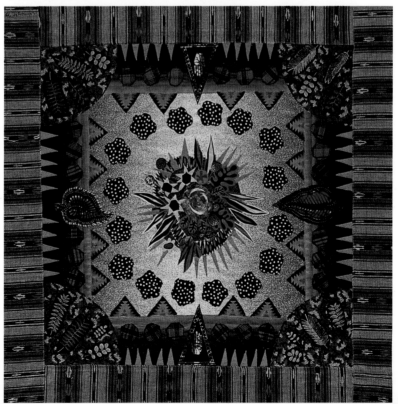

RESOURCES

Baudville
5380 52nd Street, SE
Grand Rapids, MI 49512-9765
800-728-0888

Commercial Screen Supply, Inc.
New England's Largest Screen Printing
Supply and Artist Materials Dealer
6 Kiddie Drive
Avon Industrial Park
Avon, MA 02322
800-227-1449
800-583-8234 fax

Daniel Smith
4130 First Avenue South
Seattle, WA 98134-2302
800-426-6740

Dick Blick Art Materials
P. O. Box 1267
Galesburg, IL 61402-1267
800-447-8192

Durotech
456 South Lake Boulevard
Richmond, VA 23236
800-827-1379

The Fabric Center
285 Electric Avenue
P. O. Box 8212
Fitchburg, MA 01420-8212
508-343-4402

Gold's Artworks Inc.
2100 North Pine Street
Lumberton, NC 29358
800-356-2306

Harcourt Bindery
51 Melcher Street
Boston, MA 02210
617-542-5858

Johnsons Bookbinding Supplies
32 Trimountain Avenue
P. O. Box 280
South Range, MI 49963
906-487-9522

Lee S. McDonald, Inc.
Fine Hand Papermaking Equipment
P.O. Box 264
Charlestown, MA 02129
617-242-2505
617-242-8825 fax

On Paper
3342 Melrose Avenue NW
Roanoke, VA 24017
800-820-2299

Ott's
102 Hungate Drive
Greenville, NC 27858
800-356-3289

Pearl Art & Craft Supplies, Inc.
6000 Route 1
Woodbridge, NJ 07095
908-634-9400

Pearl Paint Company, Inc.
308 Canal Street
New York, NY 10013-2572
800-221-6845 ext. 2297

Rugg Road Paper Company
Hand-Made Paper
105 Charles Street
Boston, MA 02114
617-742-0002
617-742-0008 fax

University Products
P. O. Box 101
South Canal Street
Holyoke, MA 01041
800-336-4847

Institutions with collage holdings, classes in collage or collage information:

Alaska State Museum, Juneau, AK

Albany Institute of History & Art, Albany, NY

Arts Council of Fayetteville-Cumberland County, The Arts Center, Fayetteville, NC

Center for Book Arts, New York, NY

Center of Contemporary Art, North Miami, FL

College of William and Mary, Joseph & Margaret Muscarelle Museum of Art, Williamsburg, VA

The College of Wooster Art Museum, Wooster, OH

Columbus Museum, Columbus, GA

Florence Museum of Art Science and History, Florence, SC

Fort Worth Art Association, Modern Art Museum of Fort Worth, Fort Worth, TX

Huntington Museum of Art Huntington, VW

Maryhill Museum of Art, Goldendale, WA

Maryland Art Place, Baltimore, MD

Mint Museum of Art, Charlotte, NC

Missoula Museum of the Arts, Missoula, MT

Mobile Museum of Art, Mobile, AL

Nassau County Museum of Art, Roslyn Harbor, NY

Pennsylvania Academy of the Fine Arts, Museum of American Art, Philadelphia, PA

Provincetown Art Association & Museum, Provincetown, MA

Purdue University, West Lafayette, IN

Rollins College, George D. & Harriet W. Cornell Fine Arts Museum, Winter Park, FL

Roswell Museum and Art Center, Roswell, NM

Springfield Art Museum, Springfield, MO

University of Rhode Island, Fine Arts Center Galleries, Kingston, RI

University of Southwest Louisiana, University Art Museum, Lafayette, LA

The information on this page is a partial listing from the *American Art Dictionary 1995-96 55th Edition*, R.R. Bowker, A Reed Reference Publishing Company, New Providence, NJ, 1995, p. 626.

BIBLIOGRAPHY

Ades, Dawn. *Photomontage*. New York: Thames and Hudson, 1976.

Bronner, Gerald F. *The Art of Collage*. Worcester, MA: Davis Publications, 1978.

Caws, Mary Ann, ed. Joseph Cornell's *Theatre of the Mind: Selected Diaries, Letters, and Files*. New York: Thames and Hudson, 1993.

Digby, Joan and John. *The Collage Handbook*. London: Thames and Hudson, 1985.

Hoffman, Katherine, ed. *Collage: Critical Views*. New York: State University of New York at Stony Brook, 1989.

Leland, Nina, and Virginia Lee Williams. *Creative Collages Techniques*. Cincinnati: North Light Books, 1994.

Romano, Clare, and John and Tim Ross. *The Complete Printmaker*. New York: The Free Press, 1990.

Smith, Barbara Lee. *Celebrating the Stitch: Contemporary Embroidery of North America*. Newtown, CT: The Taunton Press, 1991.

Turner, Silvie. *Which Paper?* New York: Design Press, 1991.

Waldman, Diane. *Collage, Assemblage, and the Found Object*. New York: Harry N. Abrams, 1992.

Wolfram, Eddie. *History of Collage*. New York: Macmillan Publishing Company, 1975.

Carol Andrews
232 1/2 North Fillmore Street
Arlington, VA 22201-1228

Debra L. Arter
HC 64, Box 183
South Bristol, ME 04568

Felicia Belair-Rigdon
105 No. Union Street
Alexandria, VA 22314

Jennifer M. Berringer
9300 Pine View Lane
Clinton, MD 20735

Meryl Brater
101 Franklin Street
Allston, MA 02134

Gordon Carlisle
P. O. Box 464
855 Islington Street
Portsmouth, NH 03802-0464

Erika Carter
2440 Killarney Way SE
Bellevue, WA 98004

Robin M. Chandler
Fulbright Scholar/USIS
University of Witwaters Rand
Parktown Village
P. O. Wits 2050
Parktown 2193
Republic of South Africa

Jane Burch Cochran
6830 Rabbit Hash Hill Road
Rabbit Hash, KY 41005

Sandra Townsend Donabed
130 Washington Street
Wellesley, MA 02181

Jan Fassinger
1001 Beatty Avenue, #2
Cambridge, OH 43725-1830

Ben Freeman
300 Summer Street, #75
Boston, MA 02210

Susan H. Gartrell
12 Robinhood Road
Natick, MA 01760

Susan V. Haas
2 Greenwood Street
Amesbury, MA 01913

Frances K. Hamilton
813 East Broadway
Boston, MA 02127

Timothy D. Harney
6 Berkeley Avenue
Beverly, MA 01915

William Harrington
120 Goulding Street
Holliston, MA 01746

Robert W. Kelly
144 Chambers
New York, NY 10007

Carole P. Kunstadt
470 West End Avenue
New York, NY 10024

Karen L. McCarthy
141 Warren Street
Arlington, MA 02174

Peter Madden
109 F Street
Boston, MA 02127

Therese May
651 North 4th Street
San Jose, CA 95112

Diane Miller
261 Garfield Place
Brooklyn, NY 11215

Barbara J. Mortenson
633 Stetson Road
Elkins Park, PA 19027

Emily Myerow
Fine Design Art Studio
Saxonville Studios
1602 B. Concord Street
Framingham, MA 01701

Dominie Nash
Bethesda, MD

Gina Ochiogrosso
930 Morgan Avenue
Schenectady, NY 12309

Helen Pierotti Orth
Collage Mystique
2045 Broadway
San Francisco, CA 94115

Rachel Paxton
P. O. Box 2129
Jamaica Plain, MA 02130

Linda S. Perry
Art Quilts
96 Burlington Street
Lexington, MA 02173

Deborah Putnoi
171 Fayerweather Street
Cambridge, MA 02138

Nancy Rubens
340 West 72nd Street
New York, NY 10023

Dawn Southworth
63 Bennett Street
Gloucester, MA 01930

Nancy Virbila
41 Alpine Trail
Sparta, NJ 07871-1508

Clara Wainwright
57 Upland Road
Brookline, MA 02146

Lori Warner
33 Soley Street
Charlestown, MA 02129

Ellen Wineberg
Kendall Center for the Arts
226 Beech Street
Belmont, MA 02178

Joyce A. Yesucevitz
204 Endicott Street
Boston, MA 02113

About the Author

Jennifer Atkinson received her M.A. in Art History from Boston University in 1983. She worked for a number of years at Clark Gallery, where she and her colleague Julie Bernson organized shows of found object- and collage-art. She has written book reviews for *Art New England*, a bimonthly publication. Recently, Atkinson was appointed curator of the Fuller Museum of Art in Brockton, Massachusetts.